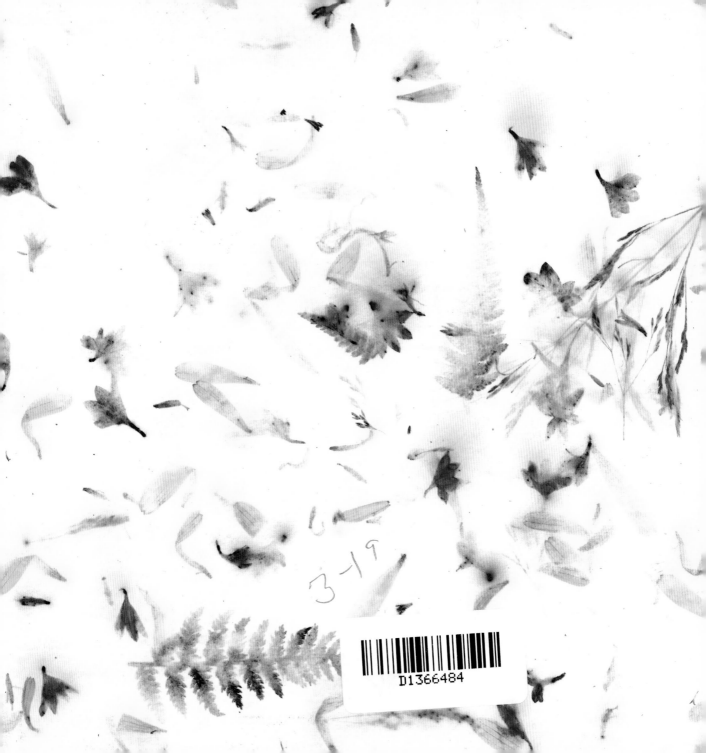

3-19

PENNY BLACK'S
THE BOOK OF CARDS AND COLLAGES

PENNY BLACK'S
THE BOOK OF
CARDS AND COLLAGES

Photographs by
JACQUI HURST

SIMON & SCHUSTER

NEW YORK LONDON TORONTO SYDNEY TOKYO SINGAPORE

SIMON & SCHUSTER
Simon & Schuster Building
Rockefeller Center
1230 Avenue of the Americas
New York, New York 10020

Published simultaneously in Great Britain
by Ebury Press, an imprint of Random House UK Ltd.,
20 Vauxhall Bridge Road, London SW1V 2SA, England.

Editor: Gillian Haslam
Design: Polly Dawes
Illustrations: Dennis Curran

Typeset by Textype Typesetters, Cambridge
Printed and bound in Italy by New Interlitho S.p.a., Milan

10 9 8 7 6 5 4 3 2

Library of Congress Cataloging-in-Publication Data

Black, Penny,
 [Book of cards and collages]
 Penny Black's the book of cards and collages.
 p. cm.
 Includes index.
 ISBN 0-671-86636-2
 1. Greeting cards. 2. Collage. I. Title. II. Title: Book of cards and collages.
 TT872.B55 1993
 745.594'1--dc20 92-354046
 CIP

SUPPLIERS

Noisy Crow Papers, 99 Beechwood Hills, Newport News, VA 23602, Tel: 804-877-2228 (hand marbled papers)

Putney Nursery, Box 265, Rt. 5, Putney, VT 05346, Tel: 802-387-5577 (seeds for wildflowers, herbs, and ferns)

Sax Arts & Crafts, 100A East Pleasant Street, Milwaukee, WI 53212, Tel: 414-264-1580

The endpaper is reproduced courtesy of Falkiner Fine Papers and manufacturer Richard de Bas.

CONTENTS

❧ INTRODUCTION ❧

T HE first printed card, conveying a message of congratulations, was printed in 1829. The first Christmas card was sent by Henry Cole, the founder of the Victoria and Albert museum, in 1843. Picture postcards were printed when the introduction of the railway system enabled more people to participate in family holidays, particularly those by the sea. When the penny post came into operation the whole business of sending cards burgeoned and by the 1890s they were being mass-produced in the thousands by the company Raphael Tuck. The sending of valentine cards, picture postcards, cards celebrating anniversaries, festivals and announcements, communications, messages and invitations and, of course, the writing of letters became a way of life for most people.

This social communication continues just as avidly today and it is an important aspect of our lives, reinforcing and perpetuating the relationships we have with our family and friends and establishing a rapport with those whom we previously did not know. In recent years pretty and decorative cards have become popular and in our busy society, with less and less free time for letter-writing, a few lines written on a well-chosen card can be just as pleasurable to receive as the conventional letter, perhaps more so if the card is propped up where it can be admired. My cards live on the shelf in the kitchen where they remind me of my family and friends. Periodically I am forced to have a clear-out, but can never bring myself to discard them and consequently cards erupt from all my dresser drawers. Such is the popularity of cards today!

Many people may wish to use this book as a guideline and as inspiration for making cards for family and friends, but some may wish to make cards on a commercial basis. If you are not already experienced in the craft, it is essential to get as much practice as quickly as possible. There is little point in launching into the creation of the most elaborate card as the first project – it is better by far to

move with caution and start experimenting with the very basic Botanical Cards on p.64. They require little experience and will give the initial surge of enthusiasm that is necessary to continue. If the advice provided in this book is followed, then those very first attempts should look quite professional and more elaborate cards can follow. Over a period of just a few days expertise will grow and so, subconsciously, will an eye for color and balance.

It is not necessary to have an extensive supply of pressed botanicals, for they can be supplemented with fragrant spices from the kitchen cupboard, seeds, ribbons and threads, and any tiny beads or sequins that are available. None of the collages in this book should prove too difficult to make, but it is most important to adopt a very lateral approach to a craft that in the past has had a very limited application; never be nervous of experimenting with any pretty snippet of anything that could enhance the artistry and interest of a collage. Of course the collages decorating these cards can easily be expanded to make larger pictures and, once experience has been gained, this becomes the natural progression, if you have the desire to attempt more demanding work.

I immensely enjoy making cards and find they are the ideal way in which to experiment with style, color and new ideas. I am a firm believer that all those who love flowers and the natural landscape possess an innate artistic ability and in many of us this remains dormant. I made my first pressed flower picture only seven years ago and although it was sadly lacking in artistry, it aroused in me a suspicion that perhaps I was capable of more. I experimented in all directions and with the manipulation of the smallest jot of craft I began to unravel an art form that now captivates me. In creating the cards in this book I have been able to experiment with all sorts of notions and I hope that they will set readers on the path to discovering more for themselves.

❧ PAPERS ❧

Over the past few years I have amassed a wide and rich collection of papers. When I first started making my collages I knew nothing of hand-made paper and I only used good quality machine-made paper as a background. However, while browsing in an arts and crafts shop one day I came upon a drawer of hand-made papers. I was immediately fascinated by their tactile rough texture and appealing ragged edges and bought a single sheet with which to experiment. So began an interest in hand-made papers, their romantic history and a strong desire to make my own one day. I also began to appreciate and learn more about machine-made papers and along my journey of discovery have experimented in all sorts of directions, finding ways in which to divide, color and use both machine-made and hand-made papers. I now place as much importance on the paper I use as on the botanicals that will decorate it.

Like many of the ancient crafts, paper-making has a romantic history. It originated in China some 2,000 years ago and the documented invention is attributed to Ts'ai Lun, a Chinese eunuch, who is credited with making the first paper pulp in the year 105 A.D. He used a maceration of natural fibrous materials that included barks, hemp, linen and cotton rags and other plant materials, eventually deciding upon old rags as being the best components. Paper-making remained the secret of the Chinese for hundreds of years but it eventually reached Japan in the eighth century A.D. where the Empress Shotuka commissioned *The Million Prayers*, the first known text to be printed on paper. It was also during this century that the secret of paper-making spread through the Muslim world to Samarkand and then on to Baghdad, Damascus and Cairo. During the twelfth century the Moors carried the craft to Spain and Portugal, but it was not established in Christendom until the thirteenth century. Many of the plants that had been used for paper-making in Asia were not available in Europe and initially paper was made from cotton and linen rags. However, with the development of the printing trade, and the demand for paper, in the early nineteenth century there began a search for a more plentiful raw material and this led to the discovery of wood pulp.

Today most of our paper is made from wood pulp and of course all paper used commercially is machine-made. Fortunately for artists and craftspeople hand-made paper is still available. A few old established companies in Europe still use the old hand method of paper-making and there are individual craftspeople who make and sell beautiful papers. However, it is from the Third World that most of our hand-made papers now come. Almost any fibrous materials can be used for paper-making and from the leaves of the water hyacinth, the trimmings of silk fabrics and jute carpets, intriguing and individual papers are being made. Many of these papers are made solely from recycled waste. I am fascinated by the variations in their thickness and texture, never minding at all if a sturdy paper dwindles to a mere tissue in places, or that the deckle-edges may display a border reminiscent of that on an old frayed blanket. This adds to the character and individuality of hand-made paper. Some papers have whole flowers, petals, seeds, ferns, grasses and tufts of wool, silk and cotton as an intrinsic part of their fabric, while others may only be speckled with seaweed, algae, straw, husks or tea. Colors are as diverse as textures and I particularly love the manila browns, sepia, ocher, sandy, ivory

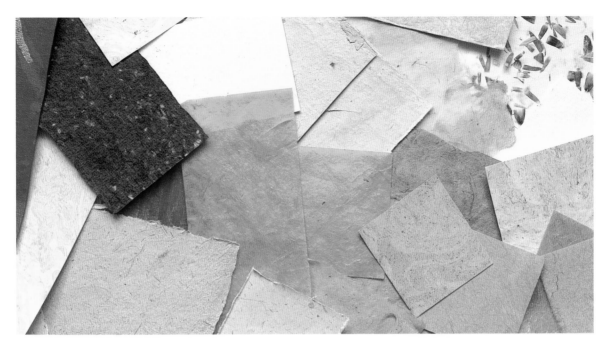

and occasionally chalk white papers. Some of the acrylic colors of the dyed papers are fun to work with, as are finely marbled papers.

Machine-made papers also have a role, for they can be colorwashed, shaded with pastels, gilded and painted. They can even be made to look like hand-made paper if the edges of a sheet of white paper are hand-torn and the paper brushed with cold tea. These papers come in all weights and colors and it is worth examining everything, even black paper can be used. But the ultimate in convenience is a pad of white watercolor or pastel papers. The sheets measure about 6×9in (15×22½cm) which, when folded, is an appropriate size for a card. These are excellent papers to use as basic cards, for not everyone is inclined towards deckle-edges and fancy papers.

Although papers do vary in weight, this never really concerns me. If a paper is too thick to fold properly then just a single card can be made or a sheet of the thick paper glued to the front of a basic card; if it is transparent or insubstantial then a sheet of this too can be lightly glued to the front of a basic card. It is the visual impact of paper that should dictate how it is used and any problem regarding weight can be overcome. However, if machine-made paper is being used for a large quantity of cards, I would recommend medium- to light-weight.

Of course there are many papers that I have not mentioned and it is a case of keeping an opportunistic eye open. White ceiling papers and some wallpapers can make interesting cards, as can brown manila and wrapping paper. All sorts of possibilities abound and they are all part and parcel of the hunt for treasure. I have become fascinated by paper but perhaps this is understandable for it is, after all, just another aspect of our use of the botanical kingdom.

❧ EQUIPMENT ❧

THE equipment needed for making these cards and collages can be quite basic, but if more elaborate techniques are to be used for applying backgrounds, then the list of paints, pastels, polishes, brushes, pens and draftsman's equipment can be quite extensive. It is best to start off with the bare necessities and gradually add to the collection as the inclination to experiment develops.

The first tool to acquire is a pair of surgical forceps. Whether dealing with fresh botanicals for pressing or dry ones for use in a collage, it is advisable to manipulate everything with forceps. Fragile botanicals are easily damaged by handling and the sooner one becomes accustomed to the use of forceps, the better. Small seeds, spices, beads and berries are almost impossible to place by hand but with forceps they can be quite firmly gripped, dipped in glue and then placed in position. Popiscle sticks, tongue depressors or orange sticks are required as in most cases one will be used to dab the glue on the back of the botanicals. Of course you need a ruler, pencil, rubber cement and a pair of scissors for measuring the card and trimming the botanicals. I do suggest that all writing is done with the finest of draftsman's pens; it is important that the end result of your labors should have a professional appearance and the use of the correct pen will complete this impression.

I believe that interesting backgrounds and colorwashed papers and cards can completely change the visual impact of botanical pictures. I use all sorts of mediums to create the desired effect. Watercolors are an obvious choice, as are the colored inks. Soft pastels produce gentle colors and I particularly like the iridescent ones. I rub them on paper and then smudge the colors with a fingertip and a stroke or two of oil pastel,

either in the same color or a toning shade. All sorts of beautiful effects can be achieved in this way. Wax crayons and colored pencils can be also used, but again I like to mix them with soft pastels.

Non-tarnishing wax gilt is available in most craft shops and its uses are inexhaustible. The polish smears perfectly over smooth papers and textured papers are left dappled gold. Metallic paints give a dense covering on paper and they are excellent to use when a narrow border is required. Gold and silver watercolors are fascinating and I find the suspension of metallic color in water can give the most delicate iridescent effect when brushed onto card. Luster powders and glitter can be sprinkled onto any surface covered with adhesive. Sheets of real gold and silver leaf are a complete luxury but I do use them occasionally as the effect is exquisite. Gold and silver spray paints are useful, particularly when botanicals need to be gilded.

A drafting pencil can save the trouble of sharpening and once acquired should last a lifetime. Narrow gold and silver pens are useful and so, too, are the wider acrylic felt tip pens. Paint brushes fascinate me although I am not an artist – I use them in variety for watercolors, distributing luster powder and glitter, spreading glue, applying polish and wax and sweeping away fragments of debris from a collage. It is good to amass a wide collection of all sizes for they will all have their use.

Glues are always a vexing question and there are many to choose from. I work with just a few and by far the most used is an ordinary rubber-based glue – it can always be rubbed or pulled off paper, the back of botanicals and even oneself if necessary. I have recently discovered Line-co

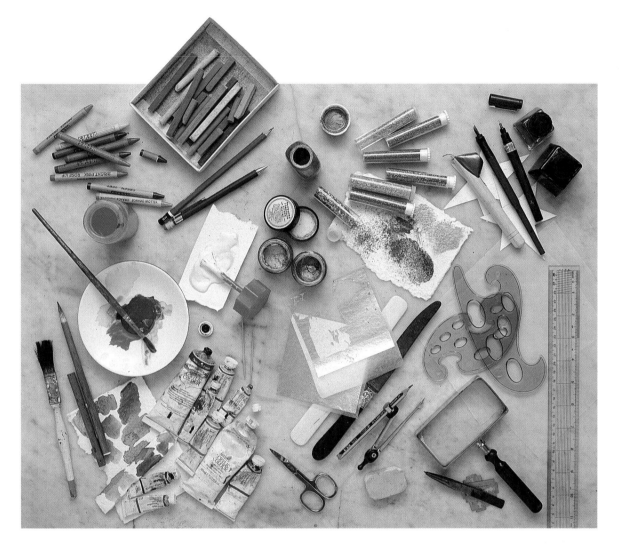

archival glue and I use it diluted to paint over flat botanicals that need some form of protection against rough handling, and also as an adhesive for glitter and luster powders. I use gold sizing as an adhesive for gold and silver gilt and to increase the transparency of tissue paper. It can also be painted over flat botanicals for protection. Spray glue has its uses, particularly when a fragile surface has to be covered with adhesive.

A good pair of craft scissors will make life easier when cutting card and botanicals, as will a craft knife or Exacto blade. A whale bone burnisher, also known as a bone folder, is easier to use than any substitute.

Finally, I would like to suggest that everyone has a magnifying glass at hand, for all my work has been inspired by a love of flowers and a detailed study of the botanical world.

❧ MAKING CARDS ❧

RATHER than buying commercially manufactured blank cards which are available in most craft shops, I prefer to make my own, choosing the paper that will most enhance my collage. Hand-made papers have immense appeal and character, but machine-made can also make excellent cards. The most important thing is how one treats the papers and what kind of cards are made.

Most of my cards and small gift tags are folded, but they can quite easily be made on single sheets of paper with the message written on the back of the design.

Cutting and tearing the paper that will be used for cards is most important and should be done well. After the paper has been measured to size, and the guidelines drawn, it can be either carefully cut with scissors, or, even better, with a paper cutter if available. If using a paper cutter, it is easier to cut several cards of the same size from one large sheet of paper. If possible I like to use the natural deckle-edge of hand-made paper on at least one side of my cards. This means that the remaining edges must be hand-torn and I have devised the following methods for doing this.

METHOD 1 – FOR ALL PAPERS
1 Fold the paper along pencil guidelines.

2 With a ruler ⅛in (2mm) from the fold, run a bone folder along the fold several times.

3 Unfold paper and carefully tear along fold.

METHOD 2 – FOR MOST PAPERS, APART FROM VERY THICK ONES
1 Take a drafting pencil and ensure that the lead is fully retracted.

2 Place a ruler along the pencil guideline and run the metal tip of pencil along it until there is a semi-perforated groove on the paper.

3 Carefully pull paper apart along groove.

METHOD 3 – FOR THICKER PAPER ONLY
1 Immerse paper on which guidelines have been drawn in water until it is saturated. Remove and dab dry with a paper towel or cloth.

2 Loosely fold along pencil guidelines. Unfold and carefully tear apart. Lay on flat surface to dry. This method gives an excellent deckle-edge.

HOW TO FOLD CARD PROFESSIONALLY
1 Fold rectangle of card in half.

2 Place a ruler ⅛in (2–3mm) from edge of the fold and, holding it firmly in place with one hand and holding a bone folder (or knife handle) with the other hand, run the flat end of the bone folder firmly along the edge of the card along the edge of the ruler, flattening and sharpening the fold.

3 Keep the ruler in the same place and using the pointed end of the bone folder and pressing firmly, run it along ruler thereby giving the edge of the flattened fold a finishing ridge.

4 If desired, this technique may also be used to flatten the outer edges of the card.

At the beginning of the list of materials, given in the instructions on how to make various

cards, I have always given the measurement of a card when folded. To work out the unfolded measurement simply double the length of the edge that runs up to the fold.

With few exceptions I use rubber cement when constructing my collages. As the botanicals will not normally have any protective covering over them they must be glued in place quite firmly, but must never lose their natural line. Nothing is more unattractive than a heavily glued picture. All stalks, leaves and buds should have their reverse side covered with small dots of glue applied with a tongue depressor $\frac{1}{2}$in (1cm) apart. Very small flowers and buds only need one dot of glue applied to their reverse center and larger flowers should have a dot applied to the center of the outer edge of the petals, $\frac{1}{16}$in (1mm) from the edge, as well. Seeds, berries and spices can be held by forceps and just dipped into glue and then placed in position. The same applies to beads, sequins and shells. Any ribbons, threads or braids should only be glued in place where absolutely necessary, or their natural appearance will disappear. Occasionally I do use wood glue for the adhesion of luster powders and glitter to a background. Spray glue is useful for covering the entire surface of a fragile botanical that must be very securely fixed; this particularly applies to skeletonized leaves.

I have never used any form of plastic film to cover the collages on my cards, which is why the method of gluing is so important. I cannot come to terms with this product and feel that it destroys the natural feel of my work and my collages are often too textured for it to work properly in any case. However, there are methods of protecting the flatter collages which I occasionally use. Diluted archival glue can be brushed

over botanical decorations and this will give a most subtle protection which is totally invisible. Gold sizing can also be brushed over them and although this is slightly visible, it makes an acceptable finish. The same also applies to aerosol matte polyurethane. Occasionally I do dip my cards in melted wax which gives a charming result for the paper takes on the appearance of vellum and the flowers are discretely veiled by the wax. A warning note is that lots of practice is needed and every fire precaution must be taken as wax is highly flammable.

There are a few rules on balance that I have discovered through trial and error, only to have found out later that these rules are, in fact, observed by most artists. Any decorative collage should be positioned slightly towards the top of its background, and if the decorated background is then to be mounted on the front of a card, then this also should be positioned slightly towards the top of the card. This also means that if the collage is signed or named at the bottom then the general impression remains balanced. The difference may only be a matter of a millimeter or two, but the difference in perspective is quite marked.

PART of the fun of making these cards and collages is the collecting of the ingredients. I certainly have the instincts of a magpie and almost every receptacle in the cottage has its occupants. Mirror-glass from India lives in a tea cup, assorted shells in a tiny jug, ribbons in a basket hanging from a beam and sequins and beads in a glass vase where I can see my collection at a glance.

The most important components of these collages are the pressed botanicals and with the exception of some tropical fruit and vegetables, nearly all can be gathered from the garden and countryside. Small rosebuds are invaluable and I grow *Rosa multiflora* and *Rosa elegantula*. I also like to dry and press larger old roses. I am constantly using the round blossoms of all the shrubby and herbaceous potentillas. Astilbes, anaphalis, anemones, blue- and pinkbells, feverfew, pink and white *Polygonum campanulatum*, celandines, buttercups, dandelions, lilac, forget-me-nots, elder flowers and various clematis are some of the smaller flowers I find most useful.

I prefer to use only small leaves and so I press *Rosa elegantula*, herbaceous geranium, ivy, maple and alpine strawberry leaves. Any interesting larger seeds I save, and I press and dry seedheads. A skeletonized leaf is a treasure and even small lacy fragments can be used. Autumn leaves can be most dramatic when displayed artistically on a collage and all sorts can be gathered and used. Interesting curved stems and tendrils will add grace to a collage and fine stalks can be used for baskets and posy stems. I always press lots of different herbs and almost always gather only the smallest sprays. Tiny sprigs of sage, mint, thyme, rue and rosemary are most appealing and I love blue borage flowers and greeny white Sweet Cicely umbels.

The various scented geranium leaves are elegantly shaped and retain their delicious perfume for a long time. Autumn-colored ferns can color most dramatically and they make lovely baskets. Grasses can look lovely when young and green or in their brown autumn colors.

I like to work with the miniscule pressed vegetables, and indeed slightly larger specimens too. Carrot thinnings are most appealing when pressed. Newly formed peas and beans, thinly sliced red cabbage, sliced okra, onions, baby sweetcorn, watercress sprigs, mustard and cress, alfalfa sprouts and slivers of globe artichoke are just a few of the vegetables worth experimenting with. Fruit, too, can be pressed. Sprays of alpine strawberries, slices of carambola, halved and sliced tiny crab apples and slices of large strawberries will usually press well. Mosses and lichens are all useful, for their colors and textures are unique. If you live near the sea then the finer seaweeds can be gathered, washed and pressed. I use lots of berries which I lightly press or just dry. I always keep an eye open for interesting barks, particularly the paper-thin ones. Aromatic cloves, whole cardamom, star anise, allspice, peppercorns and pulses are all used on my collages.

There are lots of non-botanical ingredients that can adorn these small collages. When collecting seaweeds look for tiny shells and fragments of seaglass. I have collected snippets of old decorative textiles for years and they yield beautiful old sequins, metallic threads and jet, glass and wooden beads. Old necklaces are strung with treasures and I love the tiny wooden beads of the 1920s and 30s that are often painted in dull metallic colors. It is now possible to buy narrow, pure silk ribbons and they tie into the softest bows for posies and bouquets, as do silk embroidery threads.

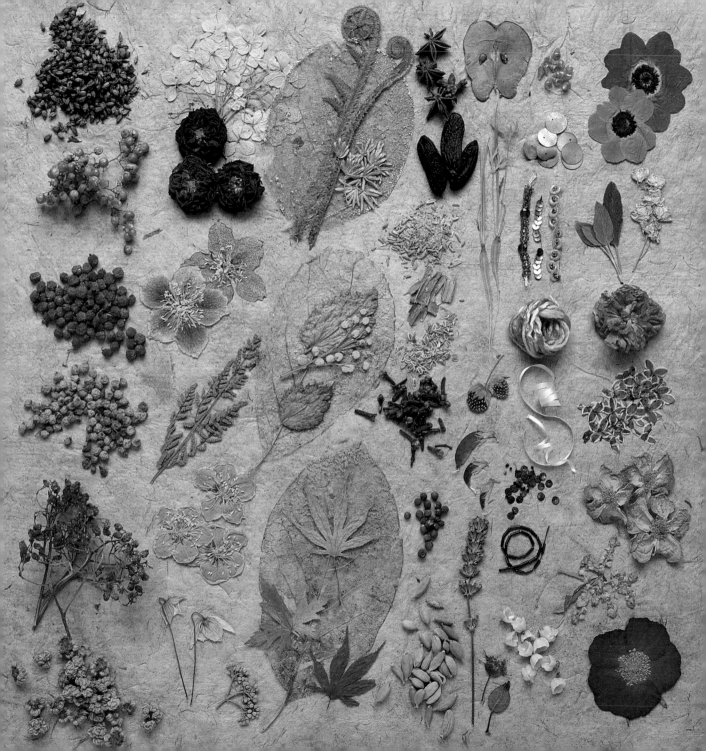

INTERESTING and imaginative backgrounds can transform the visual impact of any botanical arrangement. The backgrounds are just as important as the flowers, leaves, barks, seeds, mosses, lichens or even beads and shells that will be used to create the collage that will decorate a card. All the decorative and fine arts will fire one with inspiration, and the backgrounds and their textures and colors can become more intriguing than the actual subject matter of the work of art.

I have a large shallow florist's tray full of potential background bits and pieces. I dip into it randomly and find the most unexpected fragmentary strips of paper and card, ribbons, fabrics, threads, tubes of glitter and luster powders, spray paints and a selection of watercolors.

All sorts of fabrics can be used and I love to experiment with striped ticking, scrim, linen, silks and satins or just any fabric that will create an interesting background and elevate a botanical arrangement from the mundane to the intriguing and artistic. All fabrics should be ironed on to self-adhesive fabric backing which will prevent them fraying when cut into a shape.

Translucent watercolor washes on hand- or machine-made paper will add to the delicacy of posy and bouquet arrangements and give more importance to a single flower specimen. Thick matte watercolor backgrounds in both dull and brilliant colors can transform geometric rows of botanicals into fragments of an Indian textile or a scrap of Mexican folk embroidery; stylized arabesques of muted flowers and seedheads on a dark watercolored background can be reminiscent of ecclesiastical brocade.

I am constantly discovering new ways to manipulate these paints and have recently been experimenting with "antiquing" thick white paper. Simply immerse a large sheet of white paper in water until it is saturated (this usually takes about ten minutes). Remove the paper from the water and dab off any surplus water with a kitchen towel. The paper is then ready to be divided up into cards. It is best to divide the paper into strips and divide the strips into card sizes – this facilitates the tearing process. Fold the paper gently along the measurement guidelines and carefully pull apart. This is quite easy when the paper is soft and wet, and the result is a most effective deckle edge to the cards. While the cards are still damp, cover them with a diluted watercolor wash, paying particular attention to the torn edges of the paper where the wash should be brushed in well. Leave the cards for thirty seconds and then quickly rinse them under cold tap water. Most of the color from the center of the card will be washed away, leaving just a hint of color around the edge of the card. Dry the cards flat. This antiqued paper creates an interesting background for all sorts of collages.

Fine tissue papers, gauzy Japanese papers and transparent Indian papers can all be covered with a diluted watercolor wash too. When they have dried, they can be torn into strips, rectangles and squares. The fineness of these colored translucent papers has the quality of stained glass and all sorts of interesting effects can be created. Jagged-edged rectangles and squares can be ornamented with just one or two flowers, strips of a different length and color can be joined to form colored pennants and adorned haphazardly with flowers or neat rows of pressed vegetables, and even irregular scraps of discarded paper should be retrieved for they can become delicate landscapes for tiny flowers and seeds.

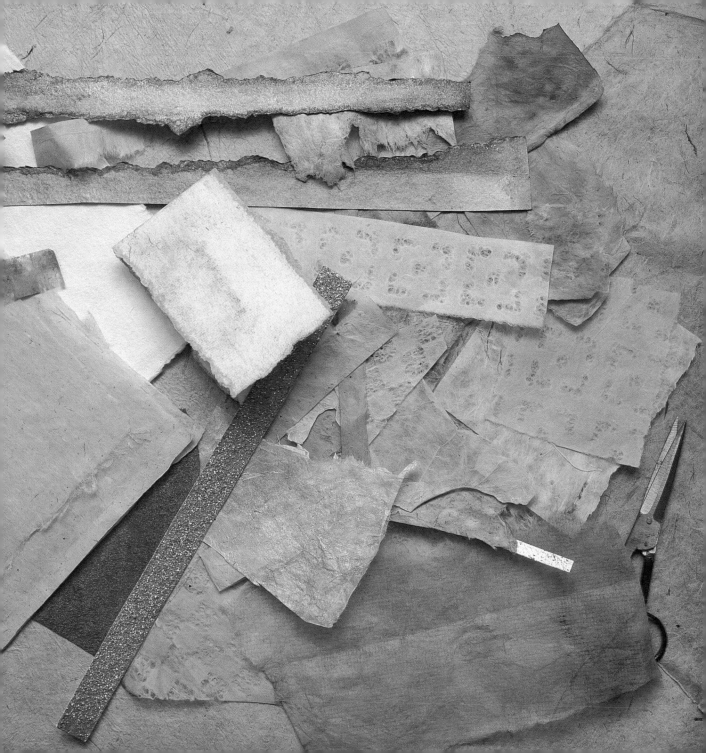

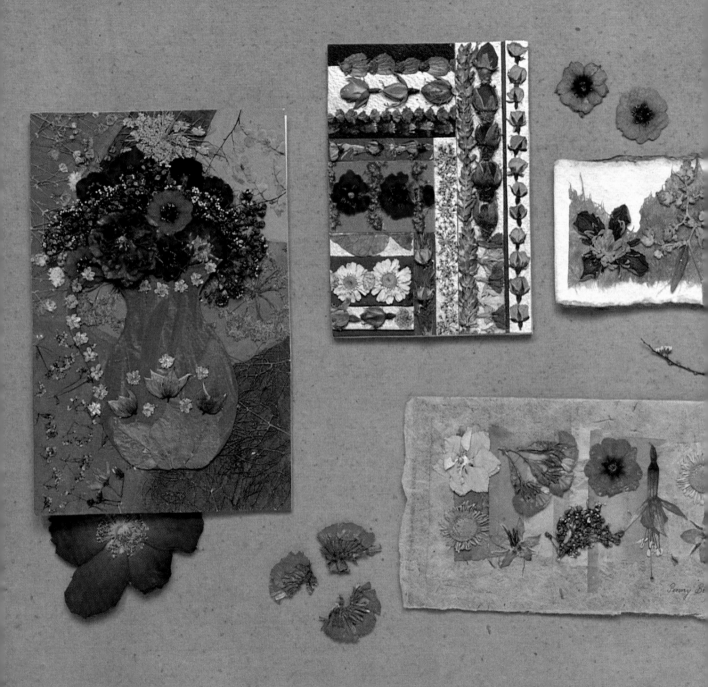

CARDS FOR
EVERY DAY

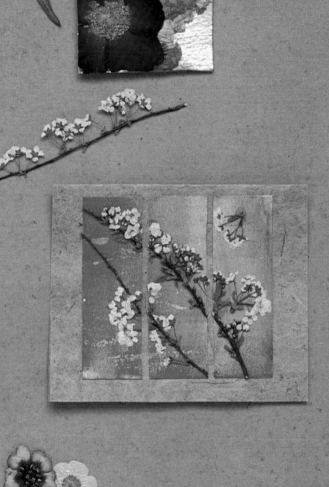

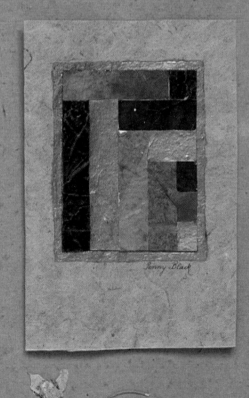

RANDOM FLOWER COLLAGES

ONE of the more unconventional ways in which I use pressed flowers is in these "random flower collages." Once these collages are made they can be cut into squares, rectangles and strips and used in a variety of decorative ways. The background is important; in the past I have used skeletonized leaves but, exquisite as they are, they are not easy to come by, and I find pure silk net, dyed black or any dark color, makes an excellent substitute. The cards are plain white machine-made paper.

RED CARD

1 Cut a 5¾ × 4in (13.5 × 10cm) rectangle from white card and colorwash it in scarlet.

2 Cover it lightly with spray glue and lay net over background, keeping the odd fold. Press onto background and trim excess away from edges.

3 Cut two long ¼in (5mm) wide strips of white card (at least 10in (26cm) in length). Colorwash one in scarlet and the other in royal blue.

4 On the background, arrange and glue botanicals, covering back of them with dots of glue ½in (1cm) apart. Group mixed blossoms fairly closely, leaving background exposed in patches.

5 Trim excess botanicals from edge of collage. Glue to front of smaller folded card, lining up left and lower edges of collage with left and lower edges of card.

6 Cut royal blue ¼in (5mm) strip to fit along top and right edges of collage. Cut scarlet strip to fit along top and right edges of blue strip.

BLUE CARD

1 On larger card draw a border of chevron stripes ½in (1.5cm) wide along top and right edges. Colorwash in somber blue, mauve and pink.

2 Cut 6 × 4¼in (15 × 11cm) rectangle of white card and colorwash it royal blue. Attach net as in step 2 of red card.

3 Arrange a random collage of flowers on background as in step 4 of red card. Trim excess botanicals away from edges of collage and glue collage firmly in place on front of card.

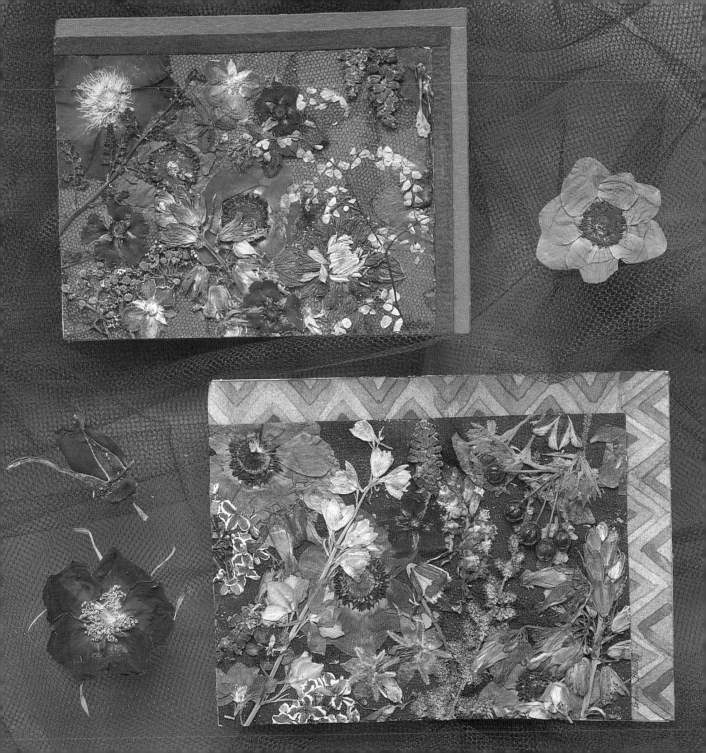

❧ AUTUMN LEAVES ❧

Ingredients

Three folded blank cards 5½ × 3½in
(14 × 9cm)

❧

Yellow colorwashed, hand-torn
translucent paper 3 × 2½in (8 × 6cm)

❧

Green colorwashed, hand-torn translucent
paper 2½ × 2½in (6 × 6cm)

❧

Strips of colorwashed, hand-torn translucent
paper in yellow, orange and apricot
3 × ¾in (8 × 2cm)

❧

Autumn leaves

❧

Rubber cement

T HESE autumn-leaf cards rely on their back-
grounds to give them a sense of style. Of
course, the more one examines the leaves the
more fascinating they become, but their impact
alone is not strong enough to create a collage.
However, when put against a background of deli-
cately toned papers the leaves take on a new sig-
nificance and their shape, color and texture
become visually more exciting. The diversity of
leaf form is infinite, and searching among the
dry autumn foliage can reveal the most unex-
pected treasures. In just a single foray you can
collect enough leaves for a lifetime of card-mak-
ing. However, part of the fun is to impose strict
discriminatory rules when gathering and each
leaf should be examined for a unique quality. But
I still bring home far too many and the kitchen
can become awash with leaves. I do, however,
press them all and now have no need to gather

any more for years. I have used maple, *Rosa
rugosa* and astilbe leaves here because I liked
their colors and textures. The cards are simple
cream hand-made paper.

MAPLE LEAF ON GREEN BACKGROUND CARD
1 Glue a hand-torn green 2½ × 2½in (6 × 6cm)
square of translucent paper to front of card,
slightly above center and position leaf on back-
ground.

2 Lift leaf and cover back with small dots of
glue ½in (1cm) apart. Replace on background
and press firmly into place.

ASTILBE LEAF ON STRIPED BACKGROUND
1 Glue in order from left to right one 3 × ¾in
(8 × 2cm) strip of orange, two of yellow and one
of apricot hand-torn paper to front of card,
slightly above center, as shown. Position leaf on
background.

2 Lift leaf and cover back with small dots of
glue ½in (1cm) apart. Replace on background
and firmly press in place.

MAPLE AND ROSA RUGOSA LEAF CARD
1 Glue a hand-torn rectangle 3 × 2½in
(8 × 6cm) of pale yellow paper and a hand-torn
strip of darker yellow paper 3 × ¾in (8 × 2cm)
on front of card, slightly above center as shown.
Position leaves on background.

2 Lift leaves and cover back with small dots
glue ½in (1cm) apart. Replace on background
and firmly press into place.

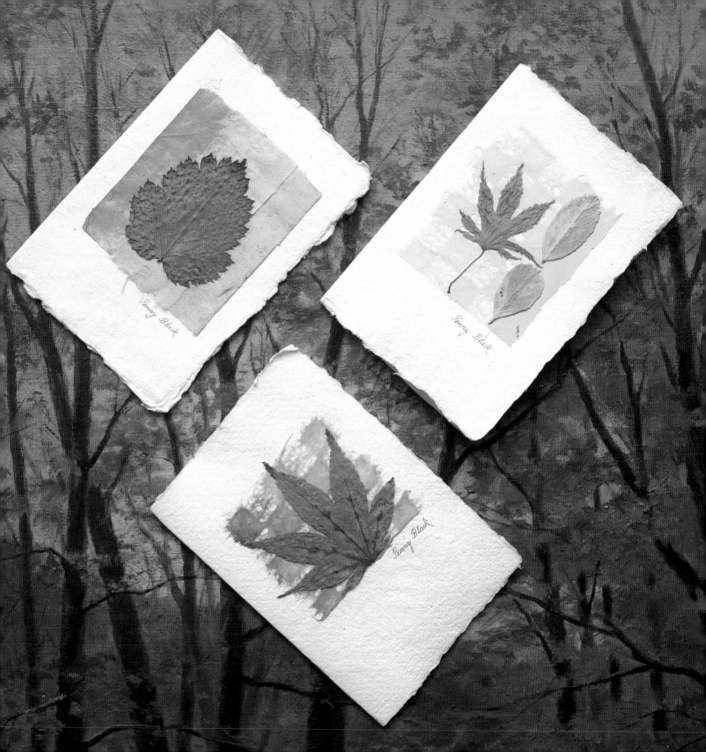

❧ ORIENTAL CARDS ❧

Ingredients

Three folded blank cards 4¼ × 3¾in
(11 × 9.5cm)
❧

White card
❧

Watercolor
❧

Rubber cement
❧

PRESSED BOTANICALS
RED CARD
Spiraea
❧

BLUE CARD
Fennel, fleabane
❧

GREEN CARD
Hydrangea paniculata

I FIND a lot of inspiration in the refined water-colors of Japan and China. My work usually displays a lot of detail and it is hard for me to leave any area unadorned, but my more recent interest in Oriental art has made me realize that the undecorated area on a collage can be as important as the decoration itself. Of course it has not been easy to come to terms with sparsely decorated collages, but they are growing on me and I am slowly finding more ways of adapting this elegant style to my own discipline. I have also found that these simple collages become even more Oriental in concept when divided into panels. Interestingly, nearly all my work can be cut into strips and re-assembled in whatever order, without detracting from its appeal in any way. The backgrounds used in these cards are colorwashed card that has been washed a second time with diluted white watercolor. The effect that these backgrounds create is quite important and much of the collages' impact is lost without this diffused color effect. The cards themselves are made from hand-made jute paper.

RED CARD

1 Cut out a rectangle of white card 3¼ × 3in (8 × 7.5cm). Colorwash in scarlet and allow to dry.

2 Colorwash in diluted white and partially rinse off under the faucet.

3 Arrange sprays of Spiraea across background as shown and glue in place.

4 Divide card into three equal sections longitu-dinally and mark with pencil lines. Cut along the pencil guidelines and glue the divided collage onto front of folded card, as shown.

BLUE CARD
Make as above card but use blue watercolor as the background and fleabane and fennel as botanicals.

GREEN CARD
Make as red card but use green watercolor as the background and *Hydrangea paniculata* as the botanical.

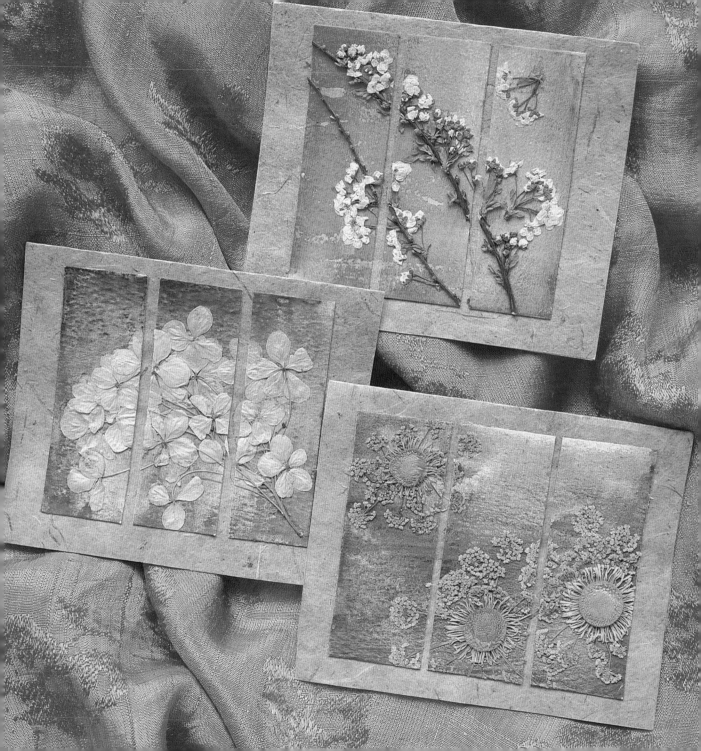

❧ FERN CARDS ❧

Ingredients

Three folded blank cards 5¼ × 3½in
(13.5 × 9cm)

❧

Selection of pressed ferns

❧

Rubber cement

❧

Fine draftsman's pen

The Victorians were great fern collectors and had many varied decorative uses for them. Arrangements of pressed ferns adorned all sorts of household articles and I am particularly fascinated by their concept of decorating windows and glass doors with them. Although I made an attempt at decorating a single pane of the kitchen window with ferns, it somehow did not look right, so perhaps I should remain with my pressed fern cards. The paper used for these cards is simple hand-made paper.

THE form and color of pressed ferns are always beautiful, but it is better to gather and press only the smallest specimens as the larger leaves can be rather coarse. Newly emerging and unfurling fern fronds are particularly lovely with their elegant and unique shape. I prefer to arrange all my ferns together for I do not find that they are shown off to their best advantage in a mixed bouquet. Here in Cornwall, England, the air is constantly moist and ferns proliferate in the thousands in our garden. Every few years I have a blitz on the terrace where the ferns seed in every available nook and cranny until there is no room for anything else. Up they all have to come, to be replanted in the less cultivated areas of the garden where they can run wild. I do have a wonderful selection from which to gather specimens in all their stages of development and wish that I had more use for them.

MIXED ARRANGEMENT OF FERNS

1 Arrange a small bouquet of mixed ferns on front of card.

2 Carefully lift ferns and cover back with small dots of glue ½in (1cm) apart. Replace and press firmly in position.

3 If desired, annotate card with fine draftsman's pen.

MAIDENHAIR FERN CARD

Make as above card but use maidenhair fern.

BRACKEN AND MAIDENHAIR SPLEENWORT CARD

Make as above card but use bracken and maidenhair spleenwort fern.

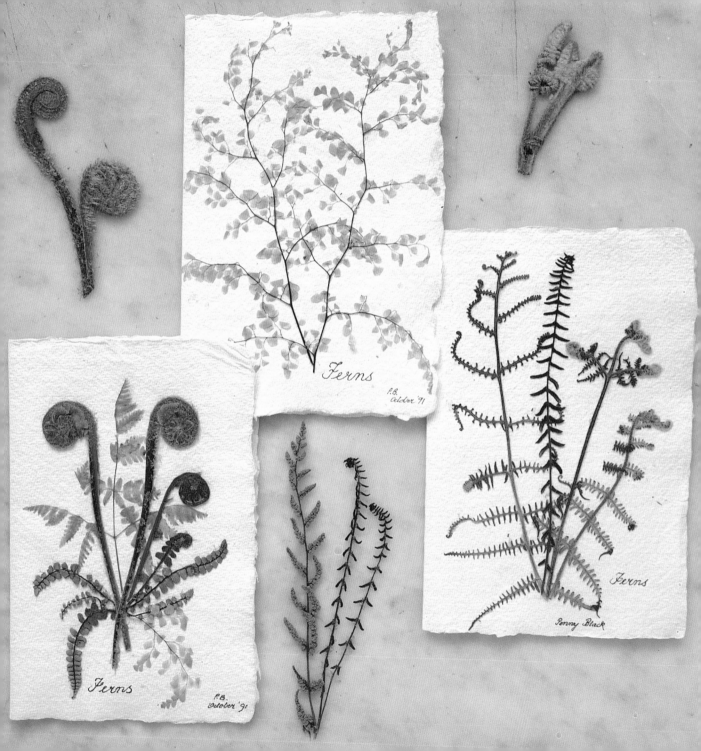

Ferns

P.B.
October '91

Ferns

R.B.
October '91

Ferns

Penny Black

⤳ HERB CARDS ⤳

Ingredients

Three folded blank cards: 6½ × 5¾in (16.5 × 14.5cm);
4¼ × 4in (11 × 10cm); 5 × 3½in (13 × 9cm)

⤳

Colorwashed translucent paper 5¼ × 2in
(13.5 × 5cm)

⤳

Pressed herbs

⤳

Fine draftsman's pen

⤳

Rubber cement

I HAVE immense pleasure in growing the herbs that have played such an important role in the lives of our ancestors. Their visual appearance is of little importance, for it is their history that enchants me. I am fascinated by the vernacular names and love to use them whenever I can. Pressed herbs have a restrained elegance and I find their subdued coloring and delicate fragrance a delight to work with.

The three herb cards in this photograph are all quite different in style but the herbs themselves, no matter how they are displayed, will always retain their intrinsic aura of healing and alchemy. I like to have as many pressed herbs as possible and always ensure that I have pressed more small specimens than larger ones. Diminutive shoots, buds, sprigs, flowers, umbels, tendrils, seedheads and leaves are essential if one is to make delicate small collages.

The lavish fan-shaped display of mixed herbs has been arranged on textured oatmeal-colored paper; the texture and ragged deckle-edge of the paper is in keeping with the natural feel of the herbs. I have used the same paper for the vertical herb arrangement. The creeping thyme card has a green colorwashed paper background which

is hand-torn, displayed on cream hand-made paper.

FAN-SHAPED HERB ARRANGEMENT

1 Assemble a large variety of pressed herbs. Build up herb collage gradually, arranging and gluing (small dots of glue ½in (1cm) apart on back of specimens) as the display develops.

2 Finish arrangement with central textured spike of herb flanked by two lateral sprigs of a prostrate herb.

VERTICAL HERB ARRANGEMENT

1 Assemble a large variety of pressed herbs. Arrange interesting specimens in a vertical design, leaving a central space for the annotation.

2 Lift botanicals and cover back with small dots glue ½in (1cm) apart. Replace botanicals on card and press firmly in place.

3 Using a fine draftsman's pen, annotate herbs using either their Latin or vernacular names beneath the arrangement of herbs.

HORIZONTAL HERB ARRANGEMENT

1 Glue 5⅓ × 2in (13.5 × 5cm) hand-torn rectangle of green paper to front of horizontally folded card, positioning it slightly above center.

2 Arrange sprigs of thyme, or any other prostrate herb, on background. Lift botanicals and cover back with small dots of glue ½in (1cm) apart. Replace and press firmly in place.

3 Using a draftsman's pen annotate the herb beneath the lower edge of the colored paper.

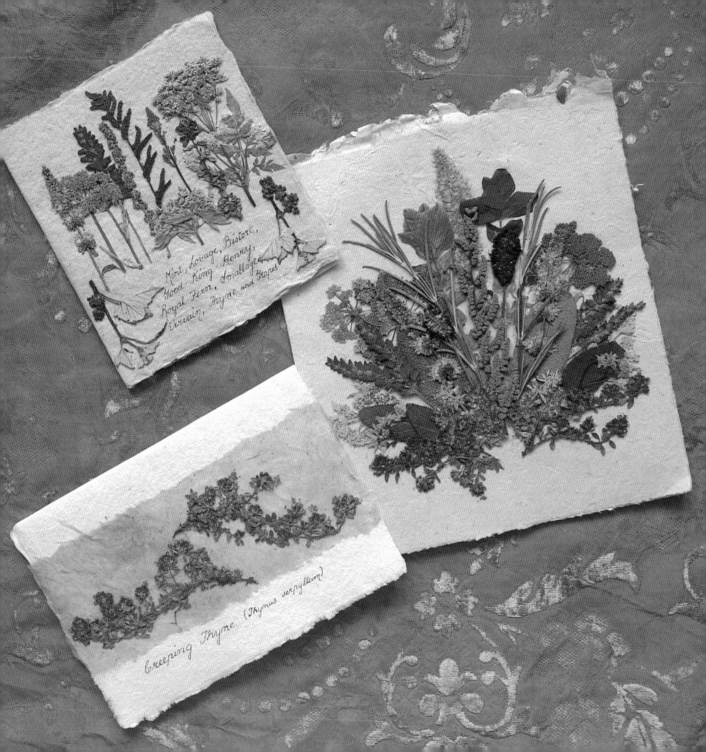

Mint, Lovage, Bistort,
Good-King Henry,
Royal Fern, Smallage
Vervain, Thyme and Tropes

Creeping Thyme (Thymus serpyllum)

BUTTERFLY AND MOTH CARDS

W HO is not fascinated by the powdered lus-
ter and exquisite patterning on the wings
of a butterfly, or the more subtle markings on the
folded wings of a moth? I have wanted to make
stylized butterfly and moth collages for a long
time and these simple cards represent my first
attempt. Given time, I would like to do some
more as their form and ornament lend them-
selves to glittering and jewellike interpretation.
Sequins and beads could combine with textured
flowers and berries on backgrounds of luster, glit-
ter or even gold leaf. I have used rough brown
hand-made Indian paper for the cards.

GREEN BUTTERFLY CARD

1 Make a card template of butterfly 4in (10cm)
long and 1½in (3½cm) deep. Draw around tem-
plate on white card and cut out shape.

2 Cover butterfly with a thin layer of archival
glue and sprinkle on green luster powder, tap-
ping gently to distribute powder evenly.

3 Arrange down center of butterfly a column of
botanicals to form body, and glue in place.
Arrange textured and flat botanicals in scant
decoration on outer wing edges. Glue in place.

4 Trim excess botanicals from edge of butterfly.
Glue onto front of horizontally folded card.

PURPLE BUTTERFLY CARD
Make as above using purple luster powder.

GREEN MOTH CARD

1 Make a card template of a moth, 2½in (6cm)
long and 1½in (4cm) wide, as shown. On white
card draw around template and cut out shape.

2 Cover moth with a thin layer of archival glue
and sprinkle on green luster powder, tapping
gently to distribute powder. Lightly spray moth
with glue and press on net. Trim net from edges.

3 Using sharp scissors divide wings from back
to just below head. Arrange botanicals as shown
and glue in place. Glue sequins in place for eyes.

4 Trim away excess botanicals from edge of
moth. Glue moth in place on front of vertically
folded card. Glue two ¾in (2cm) lengths of pea-
cock feather filaments for antennae.

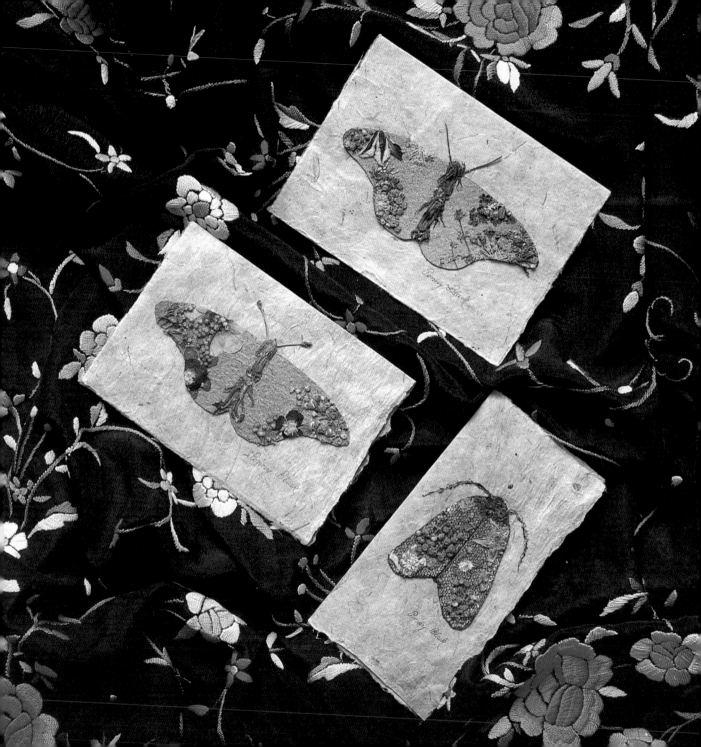

Ingredients

Two folded blank cards 5½ × 3½in (14 × 9cm)
and 3 × 2½in (7.5 × 6cm)

White card

Luster powder

Rubber cement and archival glue

Pressed large round flowers (preferably
roses)

Pressed sprays

I F you are not used to manipulating flowers it can be quite difficult to create a well-balanced flower arrangement. The flowers on these striking cards can be arranged to a preconceived plan and even if expertise is minimal, the resulting effect can appear professional. You are more limited as to the pressed flowers that lend themselves to a planned arrangement of this kind and I know of no other flower that would have the impact of the single dark red and pink roses. To make this arrangement more interesting it is important that the lower large blossom is only partially displayed, the remainder having been trimmed away level with the left-hand corner of the background. The two larger cards are handmade cream paper and coarse hand-made jute paper. As none of the paper of the small card is visible I have used machine-made medium-weight paper.

MAKING BACKGROUNDS

1 Cut out three rectangles 3 × 2½in (7.5 × 6cm) from the white card and cover them with a thin layer of archival glue.

2 Holding card level, sprinkle luster powder on and tap gently to distribute powder. Tap background vertically to remove excess powder.

PINK LUSTER CARD

1 Arrange roses in position on pink luster background, ensuring pink rose is just tucked beneath red rose and the red rose extends over the bottom left-hand edge of the background.

2 Put medium dab of glue on center back of each rose. Replace and press firmly in place.

3 When glue has dried, using sharp scissors trim off lower half of red rose level with background.

4 Where the roses do not overlap with each other, tuck behind the petals florets of pink statice on the back of which has been dabbed a couple of small dots of rubber cement. Press florets in place.

5 Using a tongue depressor tipped with rubber cement, apply two or three small spots of cement on the underside of the outer edges of each rose petal and press firmly in place. Using sharp scissors, trim statice level with edge of background.

6 Firmly glue decorated background in place on front of card slightly above center.

GREEN LUSTER CARD
Make as above card.

SMALL GOLD LUSTER CARD
Make as other cards but glue decorated background onto a card the same size as background.

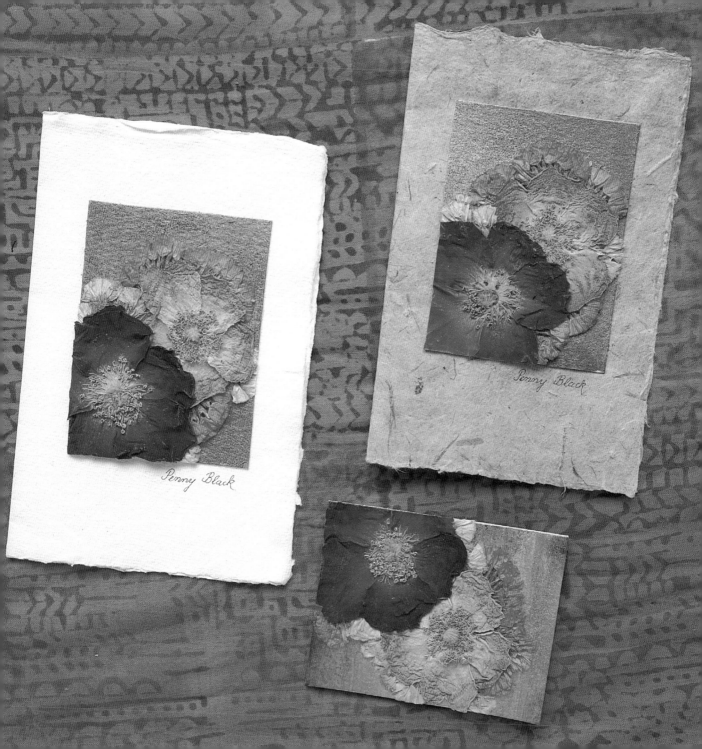

GILT BORDERED CARDS

Ingredients

Two folded blank cards 5¼ × 3¾in (13.5 × 9.5cm)

Random flower collages (see p.20) measuring:
RED
Rectangle 2¼ × 4in (5.5 × 10cm)
BLUE
Rectangles 3 × 1¼in (8 × 3cm), 3 × ¾in (8 × 2cm),
1½ × 1¼in (4 × 3cm), 2½ × ¾in (6.5 × 2cm)

White card

Gold and silver leaf

Gold sizing

Rubber cement

Two 6½in (17cm) lengths narrow ribbon

WHEN making random flower collages it is best to decorate large pieces of card that can be cut up into various sized squares and rectangles. Here I have used strips of gold- and silver-leafed card to offset sections of random flower collage. The strips could have been covered with gold or silver paint, but occasionally I like to be extravagant and use the real thing. The paper is silky hand-made Indian paper.

RED AND GOLD CARD

1 Cut a long strip at least 12½in (32cm) in length of white card ½in (1cm) wide and colorwash it in strong brick red.

2 Paint a thin layer of gold sizing over strip. While the sizing is still tacky, but not dry (test every 15 minutes – usually takes 45 minutes) apply gold leaf by placing gold-leaf tissue paper face down on tacky gold sizing. Fix gold leaf to sized card by rubbing tissue paper with a knife handle; this pressure will press the leaf onto the gold sizing where it will adhere. Remove tissue paper and if some gold still adheres to it, replace and rub again. It does not matter if the red shows as this adds to the "antiqued" charm.

3 Glue random flower rectangle to front of card, slightly above center. Surround the collage rectangle with strips of gold leaf, gluing in place.

SILVER AND BLUE CARD

1 Cut strip at least 16½in (42cm) in length of white card ½in (1cm) wide. Colorwash it medium blue.

2 Paint a thin layer of gold sizing over strip. Apply silver leaf to strip as in step 2 for gold card.

3 Glue collage rectangles onto front of card ½in (1cm) apart, with wider rectangle on the left-hand side. Surround collage rectangles with strips of silver leaf, gluing firmly in place. Glue a strip of silver leaf between two rectangles.

GIFT TAGS

1 Cut two rectangles of white card, one 3 × 1¼in (7.5 × 3cm) and the other 2¼ × 1½in (5.5 × 4cm) and colorwash in medium blue.

2 Glue collage rectangles onto center of color-washed card. Using a thick needle, thread ribbon through center of left-hand side of tags.

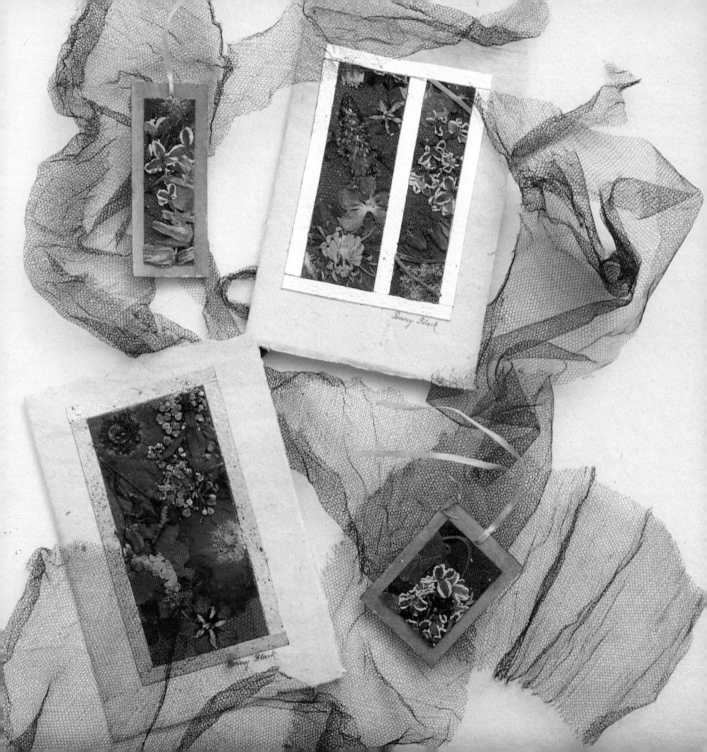

INDIAN TEXTILE CARDS

Ingredients

Three folded blank cards: two 5½ × 4in
(14 × 10cm) and one 6 × 3in (15.5 × 8cm)

White card

Watercolor

Rubber cement

PRESSED BOTANICALS
BROWN CARD
Lily-of-the-valley, feverfew, fleabane, potentilla

MUSTARD CARD
Potentilla, separated currant flowers,
hawthorn berries

ORANGE CARD
Elderflowers, potentilla, separated currant
flowers, fleabane, mimosa

INDIAN textiles have played an important role in the development of my art. I have always liked the interesting and flamboyant colors of Indian embroideries and cloth and the repetitive and stylized floral designs that ornament these textiles. Watercolor backgrounds can create the colors of naturally dyed fabrics and botanicals can be arranged in the design of embroideries or native prints. These cards have been made from hand-made Indian paper and I love its curling deckle-edges; I never trim them for they are the signature of another ancient craft.

BROWN CARD

1 Cut rectangle of white card 3½ × 2½in (9 × 6.5cm) and colorwash in barely diluted brown.

2 Arrange columns of lily-of-the-valley, fever-few and fleabane on background. Carefully lift botanicals and dab medium spot of glue on back. Replace on card and press firmly into place. Dot medium spot of glue on back of potentilla flowers and press on top of fleabane flowers.

3 Using sharp scissors, trim away excess botanicals from edge of background and glue background to card, slightly above center.

MUSTARD CARD

1 Cut white card rectangle 3½ × 2½in (9 × 6.5cm) and colorwash it in somber mustard.

2 Arrange columns of potentilla along both outer edges of background, flanked from within by separated currant flowers. Lift botanicals and dab back with medium spot of glue. Replace and press in position. Cover back of hawthorn berry spray with small dots glue ½in (1cm) apart. Position in center of background and press firmly.

3 Follow step 3 of brown card.

ORANGE CARD

1 Cut white card rectangle 4½ × 2in (11.5 × 5.5cm) and colorwash it in somber orange.

2 On lower half of background arrange horizontal rows of elderflowers, potentilla and currant flowers. Lift botanicals and dab back with medium spot of glue. Replace on background and press in position. Arrange fleabane and mimosa on top half of background. Lift botanicals and dab medium spot of glue on back. Replace and press in position.

3 Follow step 3 of brown card.

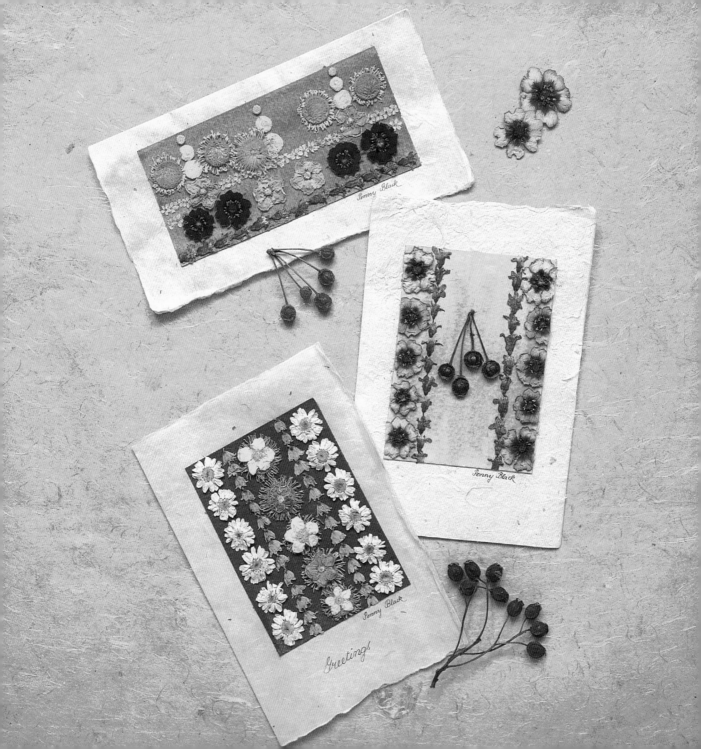

COLORWASHED TISSUE PAPER CARDS

Ingredients

Five folded "antiqued" cards 3½ × 2½in
(9 × 6.5cm) in mauve, dark pink, light pink,
green and orange

Colorwashed torn tissue paper rectangles
approximately 3 × 1½in (8 × 4cm) in mauve,
dark pink, light pink and two orange

Rubber cement

PRESSED BOTANICALS
MAUVE CARD
Polygonum, clematis

DARK PINK CARD
Pink chervil, astilbe, clematis

LIGHT PINK CARD
Polygonum, rosebuds

GREEN CARD
Clematis, fleabane, meadowsweet, potentilla

ORANGE CARD
Meadowsweet, potentilla

I HAVE had such fun making these cards. The design is new to me and I discovered it quite by chance. The artistry of these cards lies in the antiquing of the cards themselves, as described on p.16, and the use of colorwashed tissue paper. The pressed flowers would be of little visual importance without their stunning background. Using a small blank pale pink antiqued card and a scrap of pink tissue paper I arranged my pink polygonum and rosebud card in a matter of minutes. The others followed quickly and the only rule is that the base and left-hand side of the tissue paper should have a relatively straight edge. The other sides of the paper can then be as ragged as you wish – in fact this is part of their unusual charm.

MAUVE CARD

1 Glue a fragment of mauve colorwashed tissue paper more or less centrally on front of mauve antiqued card.

2 Arrange pink polygonum and purple clematis on background. Lift botanicals and cover back with small dots of glue ½in (1cm) apart. Replace botanicals and press firmly into position.

DARK PINK CARD

Make as above card using dark pink card and tissue paper, pink chervil, astilbe and clematis.

LIGHT PINK CARD

Make as first card using light pink card and tissue paper, pink polygonum and rosebuds.

GREEN CARD

Make as first card using green card, orange tissue, clematis, fleabane, meadowsweet and potentilla.

ORANGE CARD

Make as first card using orange antiqued card and tissue paper, pink meadowsweet and potentilla.

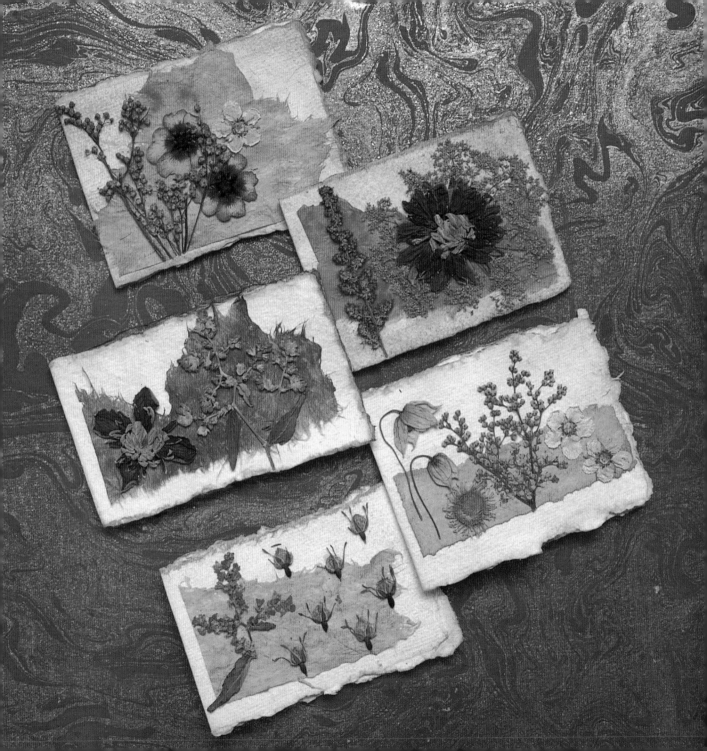

Three folded blank cards: two 5 × 3¾in
(13 × 9.5cm) and one 6¼ × 3½in (17.5 × 8.5cm)

White card and watercolor

Small beads and sequins in variety

Silver and pink luster powder

Pink glitter and gold and silver spray paint

Archival glue and rubber cement

PRESSED BOTANICALS
PINK LATTICE CARD
Clematis, fleabane, rowan berries, rosebuds,
elderflowers, heather, polygonum, potentilla

PINK STAR CARD
Elderberries, fleabane, elderflowers, fuchsia,
polygonum, geranium, sterile blue
hydrangea florets, potentilla, deutzia

SILVER STAR CARD
Rosebuds, chervil, elderflowers, *Selinum
tenufolium*, clematis, polygonum, green ivy
berries, geranium

DEEP within my psyche there lurks a delight in all things theatrical. Occasionally I will participate in that compelling world. Out will come boxes of sequins and beads; flowers, berries and leaves will be gilded and silver-sprayed and ostentatious glitter will be liberally used. Only small botanicals can be used for the gold and silver effects must remain subtle. I have used creamy textured hand-made paper for the cards.

PINK LATTICE CARD

1 Colorwash rectangle of white card 6½ × 2in (16.5 × 5.5cm) black. Colorwash several strips of card ¼in (5mm) wide pink. Cover with rubber cement and sprinkle on glitter.

2 Cut the wide pink glitter strips in half lengthways to create two ⅛in (2.5mm) wide strips. Arrange thin strips in lattice design on black background as shown. Glue in position.

3 Spray some elderflowers in silver and some in gold. Lightly spray some elderberries, flowers and buds in gold. Edge lattice strips with beads, botanicals and berries, gluing as the design proceeds and using small dot of rubber cement on back of each. Leave lower background marginally incomplete.

4 Arrange botanicals in center of lattices, leaving lower half incomplete. Lift botanicals and dab back with glue. Press into position.

5 Glue background to center of card. Edge left and right side of background with a strip of glitter ¼in (5cm) in width and glue into position.

PINK AND SILVER STAR CARDS

1 Cut out a six-pointed star approximately 4¾in (12cm) in depth, 3in (7.5cm) wide from white card. Cover in a thin layer of archival glue and, holding horizontally, shake on silver luster powder. Tap to distribute powder. Hold vertically and tap to remove excess powder.

2 Lightly spray elderflowers, elderberries and other botanicals gold. Arrange botanicals on silver star, putting berries on last. Lift botanicals and dab with glue. Press in place.

3 Trim away excess botanicals from edge of star and glue star in place in center of front of card.

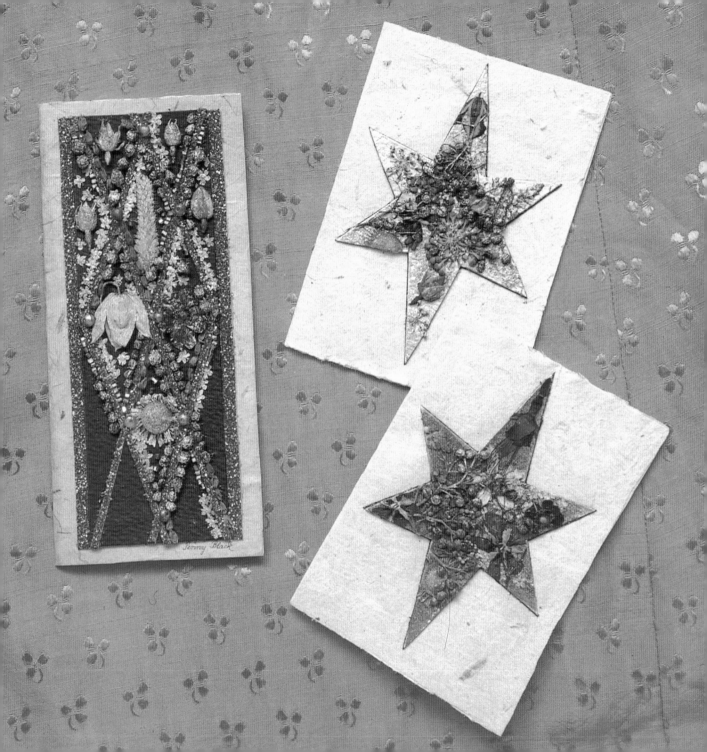

❧ STAINED-GLASS WINDOWS ❧

Ingredients

Three folded blank cards 7¼ × 2¾in
(18.5 × 7cm)

❧

White card

❧

Green, gold or silver luster powder

❧

Archival glue and rubber cement

❧

PRESSED BOTANICALS
GREEN WINDOW CARD
Sterile blue hydrangea florets, astrantia,
potentilla, roses, bluebell, dock, pink yarrow

❧

GOLD WINDOW CARD
Fleabane, geranium leaf, potentilla,
viburnum buds, feverfew, cotoneaster
berries, dock, clematis

❧

SILVER WINDOW CARD
Roses, lilac, *Cosmos atrosanguineus*, sweet
woodruff, astrantia, grape hyacinth, dock,
cardamine, spirea, clematis

M any of my collages, such as these window cards, are really like botanical embroideries. The paper is matte black watercolor paper.

GREEN WINDOW CARD

1 Cut an arched gothic window shape measuring 6¼ × 2¼in (16 × 5.5cm). Cover window with a thin layer of archival glue. Holding window horizontally, sprinkle on green luster powder and tap card to distribute powder. Hold card vertically and tap to remove excess powder.

2 Arrange on window, starting at the base, yarrow, astrantia, sterile hydrangea florets, potentilla and roses. Lift botanicals and dab on back one medium-sized spot of glue; on the hydrangea florets dab small spots of glue ½in (1cm) apart. Press in place.

3 Arrange vertical sprays of bluebell and dock on window. Carefully lift botanicals and cover back with small dots of glue ½in (1cm) apart. Replace botanicals and press into place. Trim away excess botanicals from edge of window.

4 On reverse side of window, pencil lines for panes of window, dividing it in half longitudinally and into three horizontally. Cut along pencil guidelines. Re-assemble, in correct order, on front of card and glue in place slightly apart.

GOLD WINDOW CARD
Make as above card using gold powder and different botanicals.

SILVER WINDOW CARD
1 Follow step 1 of green card, using silver powder.

2 Arrange on window, starting at base, roses, lilac, woodruff, cosmos, astrantia and grape hyacinth. Carefully lift botanicals and put one medium dab of glue on back. Press in position.

3 Arrange vertical sprays of dock, cardamine, spirea and clematis on window. Carefully lift botanicals and put small spots of glue ½in (1cm) apart on back. Replace botanicals and press firmly in position. Trim away any excess.

4 On reverse side of window, pencil lines for window panes, dividing it longitudinally into three. Cut along pencil guidelines. Re-assemble on front of card and glue in place slightly apart.

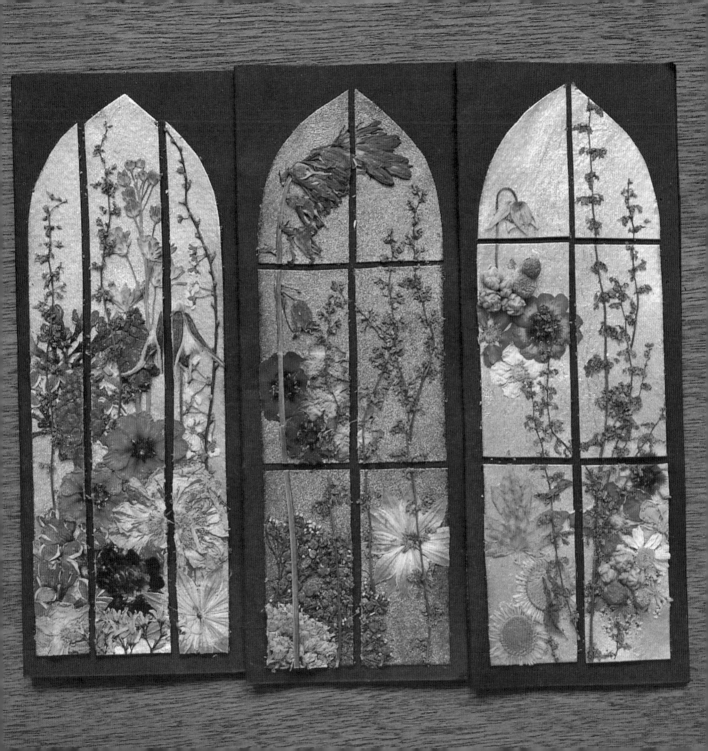

~ LAVENDER AND ROSE CARDS ~

Ingredients

Three folded blank cards – two 4 × 5¾in
(10 × 14.5cm) and one 4¼ × 5in (11 × 12.5cm)

~

Two 7in (18cm) lengths of narrow ribbon

~

Rubber cement

~

Watercolor and fine draftsman's pen

~

PRESSED BOTANICALS
FOUR-SQUARE ROSE CARD
Roses, rosebuds, rose leaves

~

LAVENDER BOUQUET CARD
Sprigs of lavender, rosebuds

~

LEAF, LAVENDER AND ROSES CARD
Roses, rosebuds, lavender spikes, double
chamomile, purple tellima leaf

A BOUQUET of roses and lavender is more traditional than any other perfume. Since time immemorial the damask rose has scented our homes and ourselves and records of the use of lavender date back to the Greek and Roman cultures. My childhood memories are embalmed in the sweet scent of the roses that climbed over our cottage and the lavender that edged the path to the front door. I grow two small roses appropriate for these cards – *Rosa multiflora* and the 'Threepenny-Bit' rose, *Rosa elegantula*. I recommend growing the palest pink and white lavender as a bouquet of mixed lavenders looks most appealing. The cards are machine-made paper, cut with scissors.

FOUR-SQUARE ROSE CARD

1 Using a draftsman's pen draw a double line border around the larger card ¼in (5mm) from outer edge. Divide the rectangle into four by drawing vertical and horizontal lines halfway inside line. Within the four rectangles, pencil another rectangle just ½in (1mm) from border's edge.

2 Using a very diluted pink colorwash paint outside the double bordered frame to the edge of the card and within the four penciled rectangles.

3 Decorate rectangles with roses, buds and leaves and glue in place. Annotate the roses.

LAVENDER BOUQUET CARD

1 Cut a ½in (1cm) strip off folded card from right-handed edge. Colorwash front of card in palest mauve and exposed edge in dark mauve.

2 Decorate edge with rosebuds and glue in place. Arrange sprigs of lavender and glue in place.

3 Tie two bows of ribbon and glue one on top of the other in the center, where sprigs cross over. Lightly glue ends of bows in place. Write "Lavender and Roses" on card.

LEAF, LAVENDER AND ROSES CARD

1 Draw a double line border around the smaller card ¼in (5mm) in from outer edge. Using a pencil, draw a rectangle within the border just ½in (1mm) from the border's edge. Colorwash the rectangle in diluted blue.

2 Arrange the botanicals, cutting the leaf at the sides and lower edge as indicated. Glue in place. Write "Lavender and Roses" beneath arrangement.

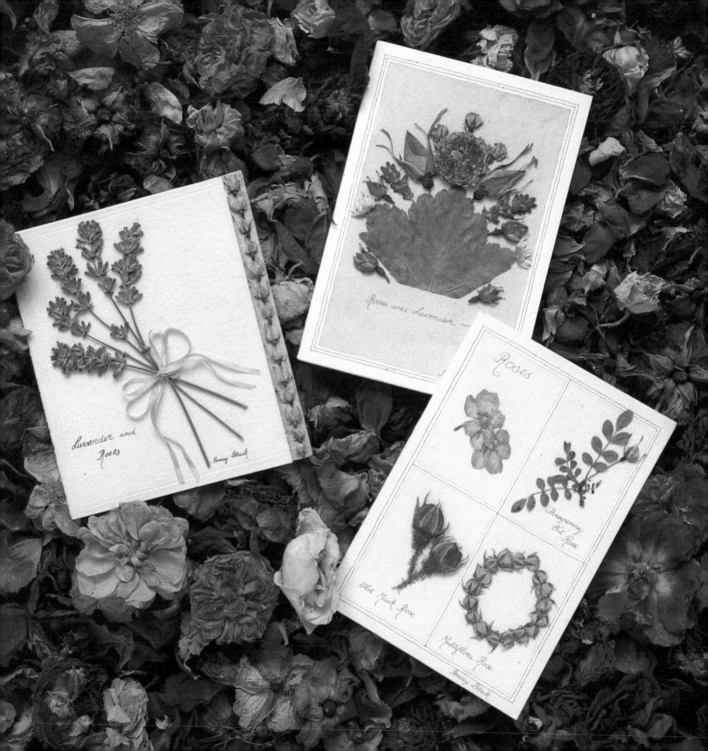

❧ GRASS CARDS ❧

Grasses can be gathered from almost anywhere. Mid to late summer sees their flower and seedheads in infinite variety with cultivated and wild grasses in the garden; midsummer meadow grasses; roadsides and banks of grasses; shaded woodland grasses; cliffs of grasses and even exciting grasses that grow in the wetlands. All the different species within the vast grass family produce quite individual flowers and seedheads and one could easily limit the ornamentation of cards to include only members from this diverse group of plants. I have not pressed a great variety of grasses, but from the minimal selection that I do have, it was quite easy to make these different cards. I have used hand-torn and hand-made jute paper, the earthy color of which blends beautifully with the brownish colorings of the grasses.

VERTICAL ARRANGEMENT OF GRASSES

1 Assemble grasses and, selecting those of a different form, arrange a variety perpendicularly on the front of a card.

2 Lift up each specimen and cover back with small dots of glue, ½in (1cm) apart. Replace in position and press firmly in place.

FAN ARRANGEMENT OF GRASSES

Make as previous card, arranging grasses in a fan-shaped display.

CORNER DECORATED CARD

1 Assemble grasses and arrange textured florets of grass on all four corners of card.

2 Lift florets and cover back with small dots of glue, ½in (1cm) apart. Replace in position and press firmly in place.

3 Arrange small bouquet of similar grasses in center of card. Lift each specimen and cover back with small dots of glue ½in (1cm) apart. Replace in position and press firmly in place.

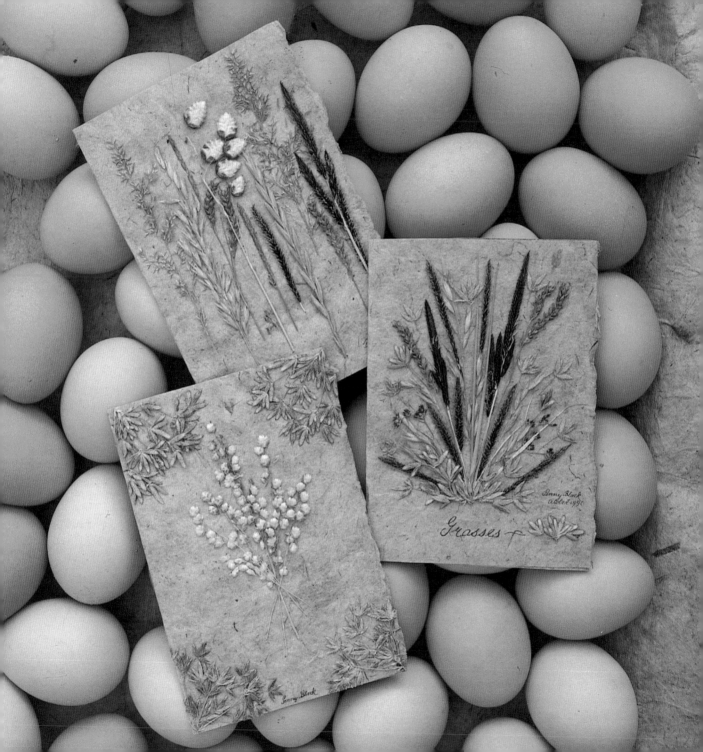

❧ FERN AND GRASS CARDS ❧

Ingredients

Two folded blank cards 5 × 3¼in (13 × 9.5cm)

❧

Tissue paper

❧

Gold sizing

❧

Rubber cement and spray glue

❧

PRESSED BOTANICALS
GRASS CARD
Selection of grasses, skeletonized leaf

❧

FERN CARD
Selection of ferns

2 Cut a rectangle of tissue paper 4 × 3in (10 × 7.5cm) and paint it with gold sizing and allow to completely dry.

3 Spray back of skeletonized leaf with spray glue. Press firmly in place over rectangle of sized tissue paper and trim edges.

4 On right side, using rubber cement, glue around edge of leaf-decorated tissue paper and place behind window on front of card and press firmly in place.

5 Arrange a small mixed bouquet of the smallest grass fronds on front of window and glue in place.

FROM early childhood I have been fascinated by detail. The finest stitchery captivates me, as does the anatomy of an insect or a posy of the most diminutive flowers. I find minute things have a unique appeal and I like to work with them. All my early pressed flower work used the smallest flowers, fronds, leaves and buds. I slowly progressed to larger things but given half the chance will return to my first love. These cards of the smallest grasses and ferns give me immense visual pleasure and although they are a challenge to handle, even with forceps, I love to work with them. Grasses and ferns can be pulled apart into smaller sections and I like to arrange them in diminutive bouquets. I used transparent backgrounds of sized tissue paper and the cards should be propped where the light shines through the collage. The cards are simple hand-made paper and rough brown hand-made paper.

FERN CARD

1 Cut a window 3 × 2in (8 × 5.5cm) in front of card.

2 Cut a rectangle of tissue paper 4 × 3in (10 × 7.5cm) and paint it with gold sizing and allow to completely dry.

3 On right side (side that has been sized) glue around edge of tissue paper, place behind window on front of card and press firmly in place.

4 Arrange a small mixed bouquet of the smallest fern fronds on front of window and glue in place.

GRASS CARD

1 Cut a window 3 × 2in (8 × 5.5cm) in the front of the card.

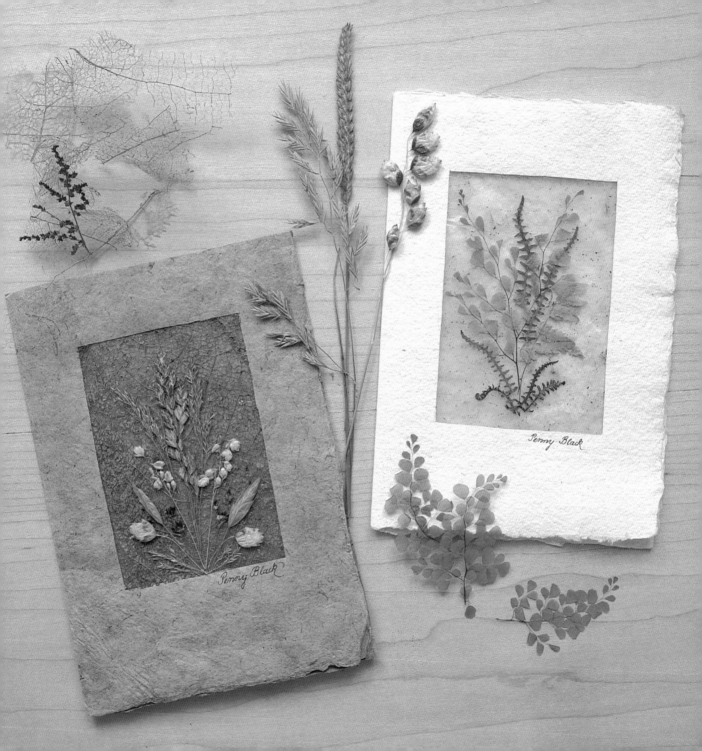

DARK MATTE FLOWER CARDS

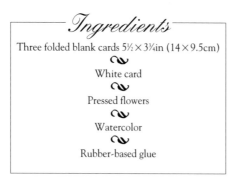

T HESE simple flower cards are quite stark and rely entirely on a mixture of dark muted colors for their impact. The somber watercolored backgrounds are an interesting foil to the rather scant displays of botanicals, which are also quite muted in color. Very few botanicals are needed for this type of card and the backgrounds in either monochrome or two-tone dingy colors are easy to prepare. The foxglove card was the first to be made. Due to their pouched flowers, foxgloves are difficult to press and I was particularly pleased with this specimen, where even some speckling on the pouches was visible. A section of any flowering stalk could have been used to make this card and of course the other two cards could have been decorated with any available flowers and given different background colors. I have used simple cream hand-made paper.

FOXGLOVE CARD

1 Cut rectangle of white card 3½ × 2½in (9 × 6.5cm) and colorwash in barely diluted dark purple watercolor and allow to dry.

2 Cut 3½in (9cm) section from a foxglove spire. Cover back of specimen with small dots of glue ½in (1cm) apart and place specimen firmly in place on background.

3 Glue decorated background to front of card.

4 Draw ⅓in (8mm) wide border around decorated background and colorwash in somber pale lilac.

BERGAMOT CARD

Make as above but colorwash background in uneven stripes as shown and use a single bergamot flower as decoration.

FUCHSIA AND ASTILBE CARD

Make as above but use fuchsia and astilbe flowers.

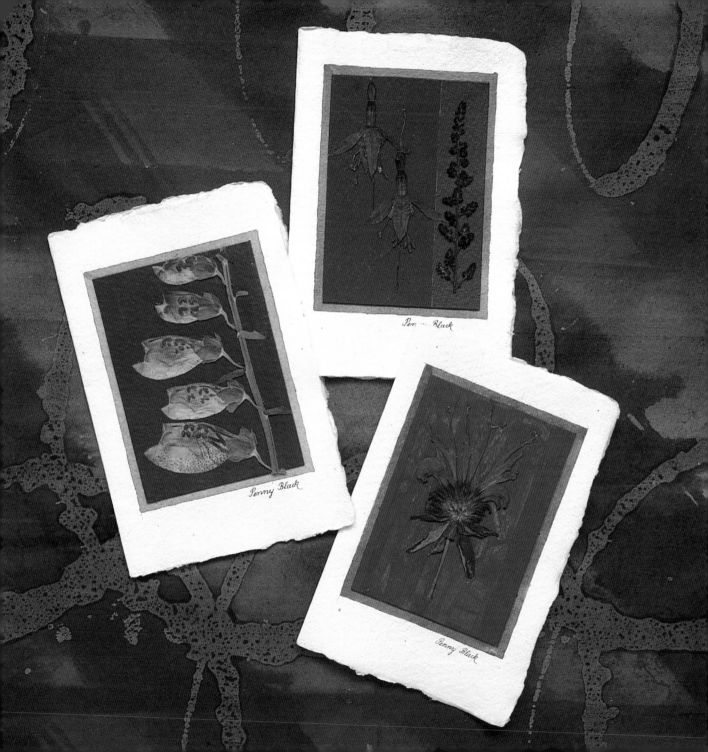

Penny Black

Penny Black

Penny Black

MEXICAN-STYLE CARDS

Ingredients

Two folded blank cards – one 6 × 3½ in
(15.5 × 9cm) and one
3 ½ × 5¼in (9 × 13.5cm)

❧

Strips of colorwashed tissue paper in
varying widths

❧

Rubber cement

❧

PRESSED BOTANICALS
HORIZONTAL CARD
Fleabane, pink-dyed statice, sterile blue
hydrangea florets, fuchsia, borage,
potentilla, pink larkspur

❧

UPRIGHT CARD
Dandelion, buttercup, geum, forget-me-not,
rosebud, grape hyacinth

As with many of my collages, this style happened quite by chance. I believe the initial inspiration came from chalky bright pinks, turquoise, oranges and yellows found on Mexican ornamental crafts which I find so stimulating. I love mixing pinks and oranges, acrylic purples and blues and throw in a few fragments of glitter and luster, and my idiosyncratic artistic satisfaction is gratified. I have days when I am compelled to work in these colors, and also when I have to wear them too!

I had at no time visualized these cards, but was just experimenting with strips of paper and brightly colored and artificially dyed flowers, when suddenly they evolved. They appeal to me immensely and I shall experiment further, adding strips of glitter paper, some luster powder and perhaps silver and gold gilt panels. I also have plans for larger collages and will no doubt have a field day with all my glittering and colorful ingredients. The cards are hand-made Indian jute paper.

HORIZONTAL CARD

1 Arrange strips of colored torn tissue paper randomly, but keeping them vertical, and glue in place.

2 Arrange pressed flowers on tissue paper, as shown on card. Lift the flowers and cover the backs with small dots of glue ½in (1cm) apart. Replace the flowers on the card and press firmly in place.

UPRIGHT CARD

Arrange and make as previous card.

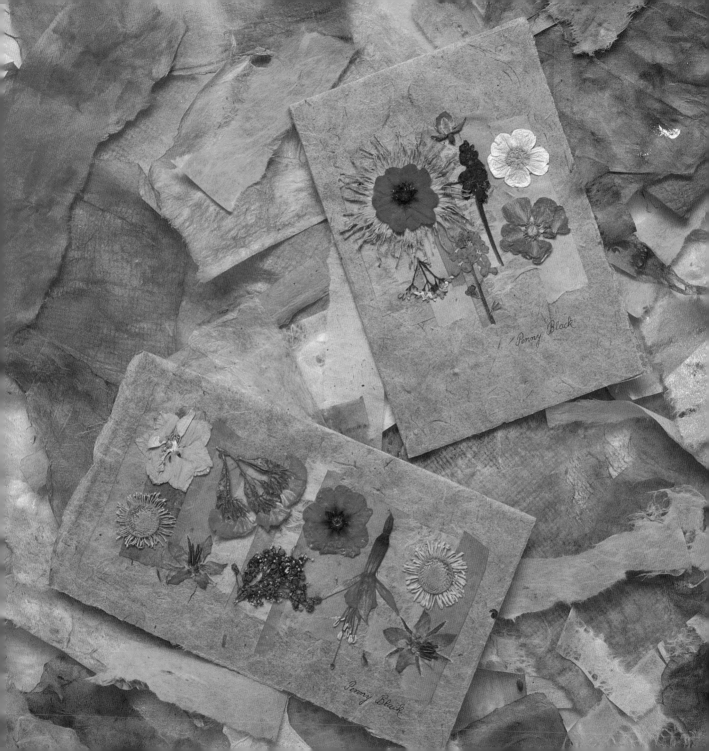

KLEE CARDS

THE geometry and coloring of much of Paul Klee's work has fascinated me for ages. His paintings reflect an imaginative law and order and his often somber use of color both soothes and intrigues my vision. The paintings fill me with ideas for collage work. Looking at the colorings of some of the autumn leaves this year I was reminded of Paul Klee's work. The leaves' leathery textures in shades of ocher, purple, russet, green-tinged-pink and plum were reminiscent of his painting *Choral and Landscape*. His painting and the autumn leaves filled me with ideas and I had to start work immediately on my version of a geometric collage, made entirely from strips, rectangles and squares of autumn bounty. I knew that the leaves would have to be reinforced in some way, and that to cut shapes of any size from them would entail using only the larger leaves. I glued them onto medium card so that there was no risk of them splitting or crumbling as I cut out my shapes. The paper of the cards is very rough hand-made jute.

STRIPED CARD

1 Using a pencil, on front of larger card draw a rectangle 3½ × 3in (9 × 7.5cm). Around the rectangle draw a border ⅛in (3mm) wide and paint it gold.

2 Glue autumn leaves onto medium-weight card. Cut out five ½ × 3in (1 × 7.5cm) strips from leaves and one strip ¾ × 3in (2 × 7.5cm).

3 Glue the strips in place within the gold border, as shown on card, with the darkest strips at the top of the card, paling to the lightest strip at the bottom.

GEOMETRIC PATCHWORK CARD

1 Using a pencil, draw on front of card a rectangle 3 × 2½in (7.5 × 6cm) and a border ⅛in (3mm) wide around the rectangle. Paint border in gold.

2 Glue autumn leaves onto medium-weight card. Cut out ½in (1cm) wide strips from leaves.

3 Cut out a ½in (1cm) wide × 4in (10cm) long strip of medium-weight white paper and paint it gold.

4 Using a Log Cabin patchwork design, as shown on card, arrange and cut strips of leaves and gold-painted paper and glue in place.

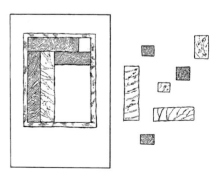

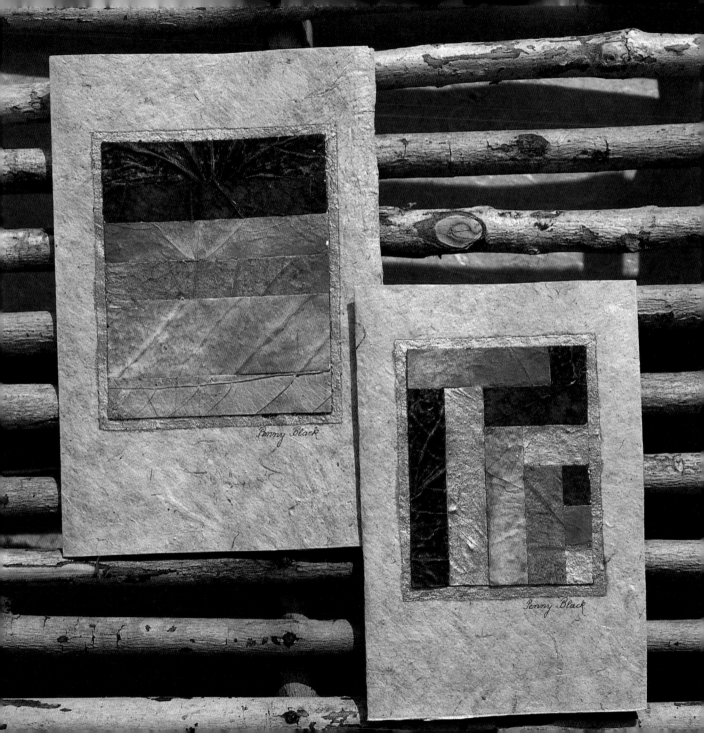

BOUQUETS ON CORRUGATED CARDBOARD

Ingredients

Two folded blank cards 4 × 6¾in
(10 × 17cm)

Corrugated cardboard

Rubber cement

8¾in (22cm) narrow cream ribbon

PRESSED BOTANICALS
BLUEBELL CARD
Bluebells, wild mignonette, whitebells
(*Hyacinthoides non-scriptus*), white
Polygonum campanulatum, *Clematis recta*,
grape hyacinth, dodecatheon, mitella

CLEMATIS CARD
Clematis viticella, lily-of-the-valley, dock

THE striped and rippled effect of corrugated cardboard can become an interesting background to a fragile nosegay of pressed flowers. The natural oatmeal color and fabric of the paper blends perfectly with subdued botanicals, creating an air of refined simplicity. Pale whitebells and dodecatheon, creamy lily-of-the-valley, silky-tasselled *Clematis recta*, green wild mignonette, bluebells, grape hyacinths and the unusual black and gray pointed buds of *Clematis viticella* are all flowers with an unusual charm. When displayed against a quiet background, their elegant form and soft coloring are not overwhelmed. The bluebells will gradually lose their color and fade to cream, as will the whitebells, but this does not matter for against their natural background they will still look pretty. In fact all the botanicals, with the exception of the grape hyacinths and *Clematis viticella*, will change color, but I love the sepia hues that develop with age. Sometimes I like to work with only faded flowers, making collages reminiscent of the bleached dimities in old patchworks. The cards are finest cream hand-made paper.

BLUEBELL CARD

1 Cut out a rectangle of corrugated cardboard 2¾in × 5½in (7 × 14cm) and glue to front of card.

2 Arrange botanicals in a loose thin arrangement on corrugated background, ensuring that some extend beyond the edge either side and glue in place.

CLEMATIS CARD

1 Arrange a thin posy of flowers on cardboard background, crossing over stalks about 1¼in (3cm) up the stems and glue in place.

2 Tie a bow of cream ribbon and glue center of bow in place where the stalks cross.

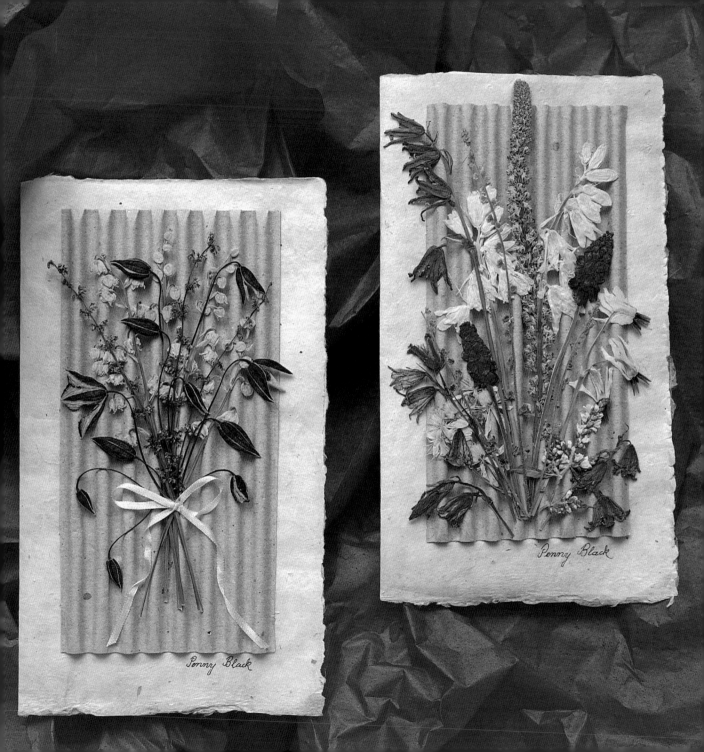

Penny Black

Penny Black

❧ BASKET CARDS ❧

Ingredients

Two folded blank cards 4 × 5½in (10.5 × 14cm)

❧

Corrugated brown paper

❧

White card

❧

Watercolor

❧

Rubber cement

❧

Agricultural peat pot, flattened

❧

PRESSED BOTANICALS
MIXED BASKET

Roses, rosebuds, white *Polygonum campanulatum*, anaphalis, potentilla, dried pink pepper berries, dried cotoneaster berries, flower stalks, moss

❧

ANAPHALIS BASKET

Anaphalis flowers, flower stalks

S MALL wickerwork baskets were part of my childhood, when I filled them with freshly gathered mushrooms, blackberries, newly-laid brown eggs, marmalade sandwiches or flowery treasures from the woods. Tiny two-dimensional baskets make charming collages and can be made from moss, lichen, ferns, peat pots, overlapping leaves, tiny bog myrtle cones, scented cloves or even an array of closely packed grass stalks. Massed blossoms of a similar variety can have almost more impact than a combination of different botanicals. I have put my basket on a background of corrugated paper which blends well with the brown hand-made paper of the cards, but almost any natural background would have been appropriate.

BASKET OF ANAPHALIS FLOWERS

1 Cut out background rectangle 4 × 3½in (10.5 × 8.5cm) of corrugated cardboard. Color-wash with barely diluted dark blue watercolor and glue onto the front of a card.

2 Cut out peat pot basket 1½in (3.5cm) at base, 2½in (6cm) at top and 1½in (3.5cm) in depth.

3 Arrange on basket a latticed decoration of fine flower stalks, trimming them so that they do not project over edge of basket, and glue in place. Glue two thicker stalks horizontally above and below base and top of basket.

4 Glue basket onto background. Fill basket with anaphalis flowers, gluing as collage progresses, and working down from the top. Allow flowers to tumble over the top of the basket.

GREEN MOSS BASKET

1 Cut out rectangle 4 × 3½in (10.5 × 8.5cm) of corrugated card and glue to front of card.

2 Cut out basket from white card measuring 1½in (3.5cm) at base, 2½in (6cm) at top and 1½in (3.5cm) in depth. Glue moss to front of basket, entirely covering surface. Trim excess from edge of basket. Cover basket with lattice arrangement, as for previous card. Glue to background.

3 Gluing as the arrangement progresses, fill the basket from the top down, mixing buds, berries and flowers and allowing them to spill over the top.

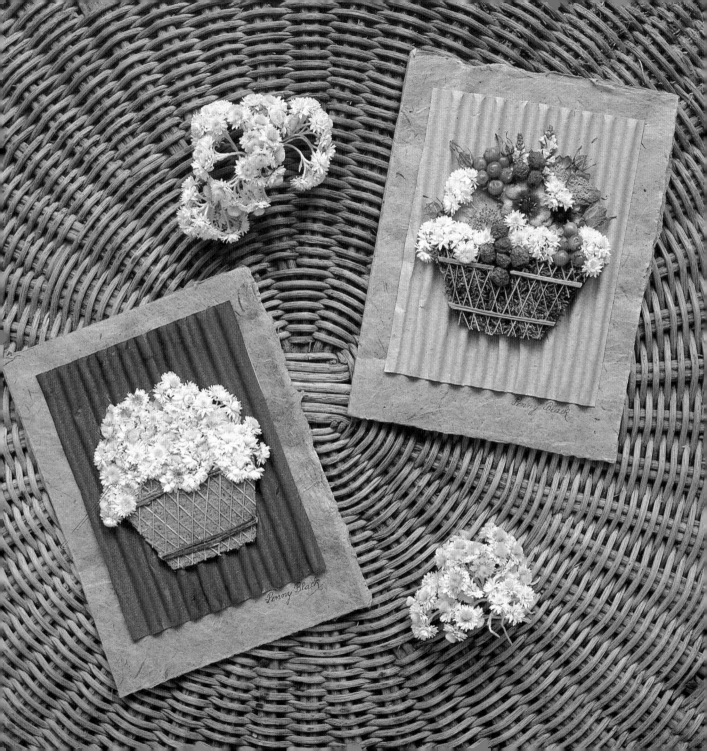

ORNAMENTAL BORDER CARDS

Ingredients

Two folded blank cards 5 × 3½in
(12.5 × 9cm)

White card

Watercolor

Gold and silver paint

Rubber cement

Good selection of small pressed
botanicals such as:
Rosebuds, lavender, achillea, *Clematis
tangutica*, *Alchemilla mollis*, potentilla,
fleabane, feverfew, gypsophila, *Selinum
tenuifolium*, delphinium, geranium, elder
flowers, astilbe, polygonum, dock

My fascination with embroidery and needle-work manifests itself in all my botanical collages. For as long as I can remember I have collected fragments of embroidery and intricate sewing, snippets of ribbons, tapes and gimps and any old pieces of fabric or patchwork, regardless of condition, that reflect the dedication of a bygone era. These textiles are a constant source of inspiration and I apply their decorative charm to so much of my work. I gleaned the inspiration for these cards from a beautiful Log Cabin patchwork of Victorian embroidered ribbons. I colorwashed card strips of varying widths in all sorts of colors and then decorated them with botanicals, ensuring that there was a repetitive theme to the design. I then arranged these pretty "botanical ribbons" in a rather haphazard Log Cabin design, cutting them to the appropriate lengths. Each snippet of "botanical ribbon" can be used and they mingle so delightfully regard-less of color and design that it would be impossi-ble not to make a success of these cards. Of course the borders themselves are quite painstaking to make, but once a good selection is at hand these most unusual collages can be assembled in just a few minutes. My cards reflect separate gold and silver themes, but they would have looked just as lovely mixing the metallic colors. These botanical patchworks have been glued onto the face of white machine-made paper cards.

GOLD AND RED CARD

1 Cut 6in (15cm) long strips of white card ¼in (5mm), ½in (1cm), ¾in (2cm) and 1¼in (3cm) in width.

2 Colorwash the strips in gold, silver, black, red, blue, green and purple or any selection of these colors. Put to one side one or two ¼in (5mm) and ½in (1cm) black strips which need not be decorated.

3 Decorate strips of colorwashed card with rows of pressed flowers and leaves, remembering to keep a repetitive theme.

4 Cut out rectangle of white card 3½ × 5in (9 × 12.5cm). On rectangle of card arrange decorated strips in a design similar to a Log Cabin patchwork, occasionally using undecorated black strips to highlight the design. Cut the strips to the appropriate length as the design progresses. Glue strips in place. Glue decorated Log Cabin rectangle to front of card.

SILVER AND BLUE CARD

Make as gold and red card.

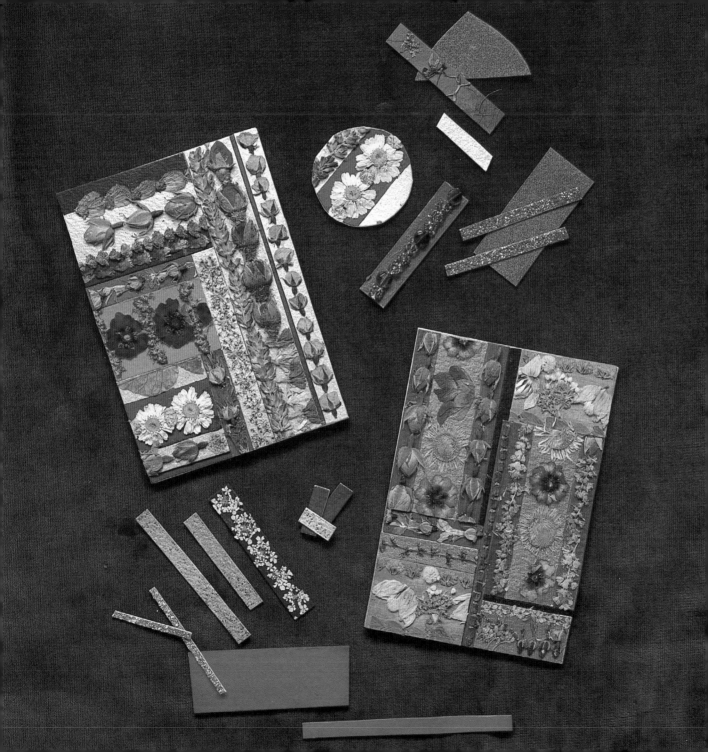

❧ COTTAGE GARDEN CARDS ❧

Ingredients

Two folded blank cards – one 5¼ × 6¾in
(13.5 × 17cm) and one 4½ × 6in (11.5 × 15.5cm)
❧

Brown paper and white card
❧

Watercolor
❧

Rubber cement
❧

PRESSED BOTANICALS
COTTAGE GARDEN CARD
Moss, lichen, potentilla, *Clematis tangutica*,
elder flowers, woodruff, anaphalis, pink
Polygonum campanulatum, feverfew, mitella,
maidenhair fern, astilbe, forget-me-not,
filipendula, geranium leaves, astrantia, fuchsia

WINDOW CARD
Moss, maidenhair fern, roses, astilbe, blue sterile
hydrangea florets, *Selinum tenuifolium*,
potentilla, double cardamine, grape hyacinth,
white *Polygonum campanulatum*, fuchsia

I STARTED making these cottagey collages six years ago. They were my introduction into the world of decorative botany and for a period of time they were the only style that I could execute, having no desire to participate in the rather stylized pressed flower work that is fashionable. However, as my familiarity with pressed and dried flowers grew, so of course did my confidence, and I was able to experiment with other somewhat revolutionary ideas that were hatched as I worked away on my "Cottage Garden" collages. My technique and style has changed a lot since those early days, but I retain a deep affection for this style. Almost all pressed flowers, buds and leaves can be used and small tufts of moss and lichen, if available, too. Although the impression may be of wild abandon, there is a positive structure and order to this style. Texture, color, form, depth and height must be taken into account and it would be advisable to get a little practice before launching into these collages. My cottage garden card is really just three glimpses of my flower borders in high summer, crammed with both wild and cultivated flowers. The cottage window card carries through the same theme. The cottage garden card is made of fine beige hand-made paper and the window card is of white machine-made paper.

COTTAGE GARDEN CARD

1 Draw three horizontal pencil lines on front of card, 1½in (4cm) apart, from one side of card to the other.

2 Arrange a crowded display of botanicals along pencil guidelines, trimming their base so they lie level with guidelines. Glue in place.

COTTAGE WINDOW CARD

1 Cut out rectangle of white card 4 × 5¼in (10 × 13.5cm) and colorwash sky blue.

2 Arrange botanicals on blue background as shown on finished card and glue in place.

3 On back of collage pencil longitudinal and horizontal lines, halfway down and across card. Using sharp scissors cut along guidelines.

4 Cut background rectangle of brown paper 4¾ × 6¼in (12 × 16cm) and reassemble panes of window in center of brown paper, leaving ¼in (5mm) gaps between panes. Glue in place.

5 Glue background to front of white card.

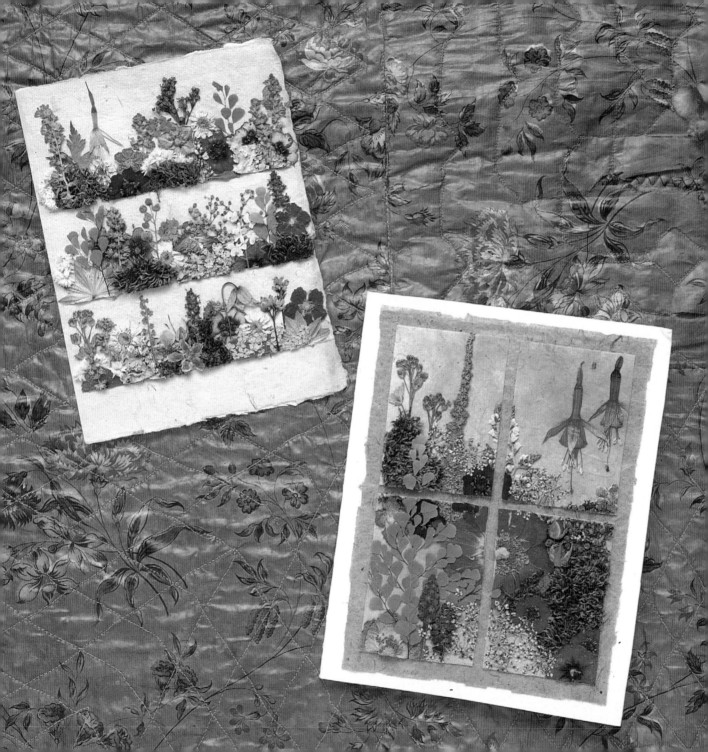

❧ BOTANICAL CARDS ❧

Ingredients

Three folded blank cards – 5×4in (13×10cm),
6×4in (15.5×10cm) and 2½×1¼in
(6×4.5cm)

Brown paper strips 1½×½in (4×1cm)

Fine draftsman's pen

Embroidery cotton

Rubber cement

Whole pressed plants

Pressed flowers

As an amateur botanist I always like to examine every aspect of a plant's construction and growth. Flowers, buds, stalks, leaves and roots take on a new dimension when studied individually; one becomes more aware of the order of nature. Each component of a dissected flower is beautiful in itself and when displayed together they reinforce botanical knowledge. The inspiration for these botanical cards has been taken from the illustrations of early botanical books, where detailed and beautiful drawings illustrate the floral kingdom. The plants displayed on these cards are complete specimens, including their whiskery roots. On the cardamine card alongside the plant I have displayed a single flower, leaf and group of buds which add to the botanical interest of the card. The gift tag

was made in the design of a small card and I used flowering sprig of herbaceous geranium because I liked the purple flower and the interesting whiskers of the developing seed capsule. Any small plants are suitable for these cards. I have used simple cream hand-made paper.

CARDAMINE CARD

1 Arrange entire plant and separate flower, leaf and buds on card.

2 Lift botanicals and cover back with small dots of glue ½in (1cm) apart. Replace botanicals on card and press firmly in position.

3 Using a fine draftsman's pen outline edge of 1in (4cm) long strip of hand-torn brown paper. Glue strip of paper alongside plant specimen and, using fine draftsman's pen, annotate plant in Latin name.

VIOLET CARD
Same method as above.

GIFT TAG

1 Arrange flower on front of tag.

2 Lift botanical and cover back with small dots glue ½in (1cm) apart. Replace botanical and press firmly in place.

3 Thread a short length of cotton through top of tag.

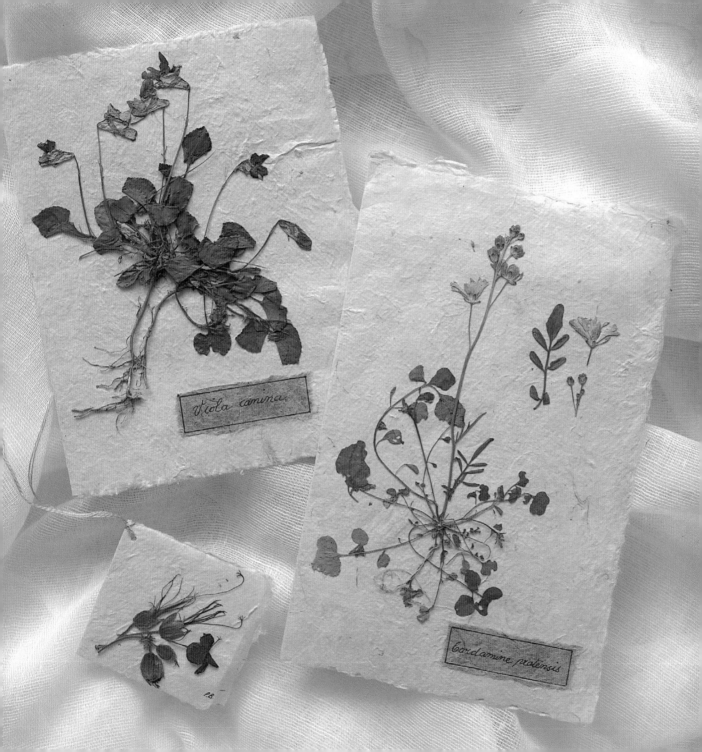

Viola canina

Cardamine pratensis

SCENTED SPICE CARDS

FOR a long time I have had an inclination to make large collages of interesting and varied spices. Not only would they smell delicious but the spices themselves would evoke the romantic flora of exotic, faraway places. I have never succeeded with my large collages so I must content myself with decorating cards using the spices from my kitchen cupboard. It really does save a lot of time and trouble having the ingredients ready and waiting in the kitchen; no drying, gathering or pressing to be done, just the pleasure of arranging the little botanicals on a card. I feel that there is plenty of scope in this spicy field, but to date I have only had time to make a few cards. The spices used on these cards are cloves, cinnamon bark, star anise, anise seeds, allspice, coriander and lavender. I have included rosebuds and scented geranium leaves in my collages, but they could have been omitted. All these were the ingredients readily available to me, but other spices could have been used. The card paper is quite primitive and its surface and deckle-edges are littered with tousled fibres; I love it and find it borders my tiny spice collages most appealingly.

LARGE SPICE CARD

1 Glue hand-torn 4 × 1½in (10 × 4cm) tissue paper rectangle to front of horizontally folded card.

2 Arrange spices on background and position scented geranium leaf and rosebuds.

3 Lift botanicals and cover back of spices and rosebuds with medium dab of glue and other botanicals with several small dots of glue ½ in (1cm) apart. Replace botanicals on background and press firmly into place.

SMALL SPICE CARD

Make as above to step 3. Tie narrow red silk ribbon around the star anise and attach to the top of the card.

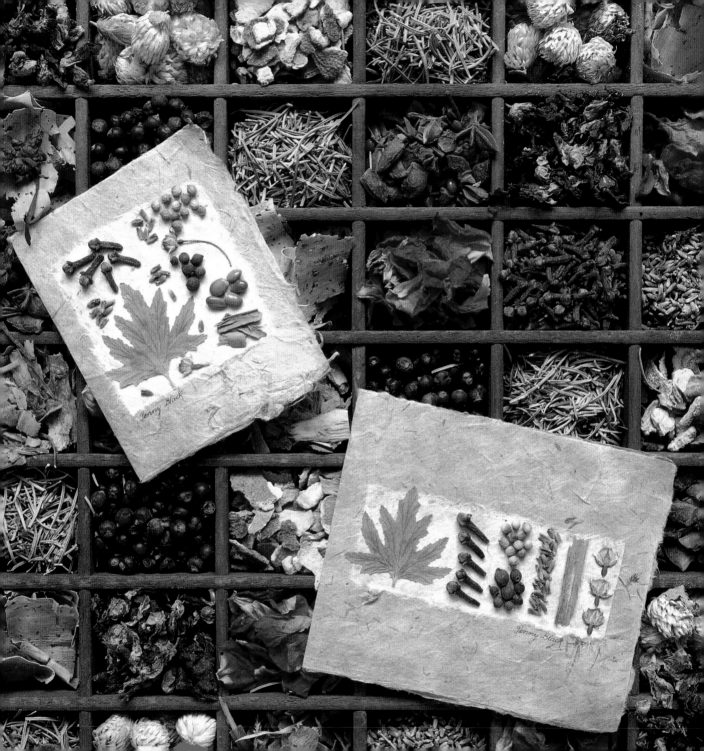

~ TICKING CARDS ~

Ingredients

Two folded blank red cards 6 × 3¾in
(15 × 9.5cm)

~

Interfaced ticking 3½ × 2½in (9 × 6.5cm)

~

Black watercolor

~

Rubber cement

~

Small flowers, buds, berries

MY inspiration for these cards comes from the ticking work embroidery of the eighteenth century, with the black stripes of the ticking making an ideal background for floral embellishment. The flowers, buds, berries and leaves that I have have used adorn the ticking in the style of the rich Middle Eastern embroideries of the past, creating interesting mosaics of color. The more diverse the collection of small jewel-colored botanicals, the more freedom there is to create flamboyant and rich designs. I never work to any pre-conceived plan or design, but just let my instincts guide me and the most unlikely designs and color combinations evolve. On these cards large and small rosebuds, potentilla, feverfew, polygonum, astrantia petals, mimosa, clematis buds and elderberries decorate the ticking but the selection is endless. The paper I have used is lightweight red card, cut with scissors.

1 Assemble a variety of small jewel-colored botanicals.

2 Glue ticking background to front of card slightly above center.

3 Arrange botanicals and glue in place a row at a time, using a medium dab of glue to fix them to the ticking. Press firmly in place.

4 Around the decorated ticking background rule a pencil border ⅛in (3mm) wide. Colorwash it with barely diluted black watercolor.

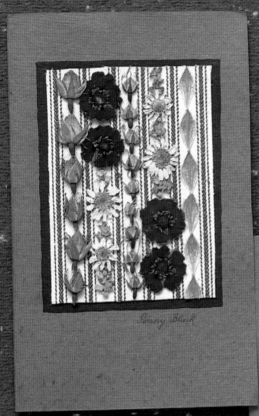

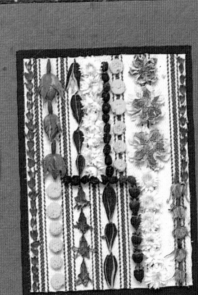

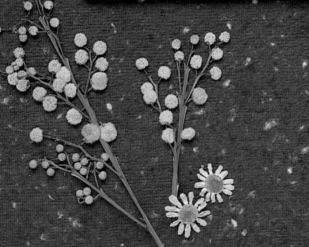

STILL LIFE CARDS

Ingredients

Two folded blank cards – 4½ × 6¾in
(11.5 × 17cm) and 5 × 6¾in (13 × 17cm)

White card

Watercolors

Gold leaf and gold spray

Rubber cement

PRESSED BOTANICALS
BLACK JUG CARD
Alchemilla mollis, lilac 'Sensation', sterile blue
hydrangea florets, roses, potentilla, pink
Polygonum campanulatum, gold laced primroses,
fennel, elder flowers, dried cotoneaster berries

TURQUOISE JUG CARD
Pink gypsophila, roses, potentilla, sea
carrot, sterile blue hydrangea florets, elder
flowers, *Clematis tangutica*, woodruff, fennel
leaves, maidenhair fern, pink chervil,
bougainvillea, woody nightshade

I HAVE been interested in the fine arts for a long time and love to browse through my many books on the artists I most admire. Many ideas for my work have blossomed from the seeds sown within my subconscious by the inspired work of others and the natural landscape. When I made these still life cards, with their unusual decorative backgrounds of strident colors, I was following my own inclination. However, I was recently looking at some paintings and collages by Matisse, whose colors, subject matter and techniques have always fascinated me, and was suddenly aware that my inspiration really came from his work. The cards are white machine-made paper.

BLACK JUG CARD

1 On front of larger card pencil guidelines for separate sections of background and colorwash.

2 On white card draw handled jug 3½in (9cm) high and cut out. Colorwash matte black. On white card cut out small pot 2in (5cm) high and cover with gold leaf, as per instructions on p. 34.

3 Arrange botanicals on different background sections, as shown, and glue in place, leaving background bare where the jug and pot will be. Position jug and pot and glue in place. Decorate jug with elderflowers and glue in place.

4 Arrange the flowers and berries in the jug, as shown, and glue in position as the collage progresses, starting at the top and working down so the botanicals spill over the lip of the jug.

5 Fill gold pot with potentillas in same manner, and glue in place. Trim away any overhanging botanicals from the edge of the card.

TURQUOISE JUG CARD

1 On smaller card pencil rough guidelines for separate sections of background and colorwash. On white card draw and cut out jug as for previous card and colorwash turquoise.

2 Arrange botanicals on different background sections, as shown, and glue in place, leaving the background bare where the jug will be.

3 Position jug on background and glue in place. Decorate jug with elder flowers sprayed gold and other botanicals. Fill jug with botanicals and glue in place as for black jug.

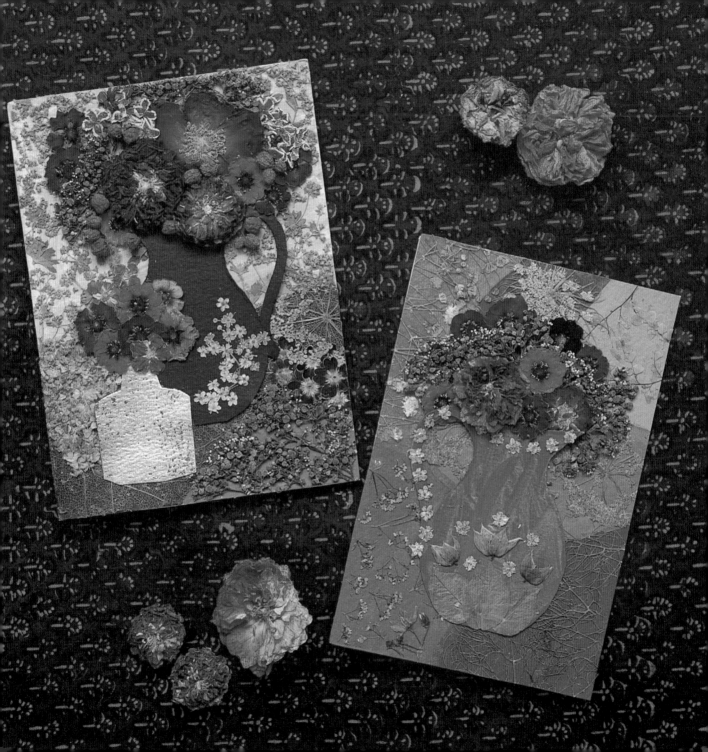

VEGETABLE AND FRUIT CARDS

Ingredients

Three folded blank folded cards 5½ × 3¾in
(14 × 9.5cm)

❧

Colorwashed translucent paper, hand-torn
into strips

❧

Fine draftsman's pen

❧

Rubber cement

❧

PRESSED VEGETABLES
Carrots, okra, beans, green tomato, baby
sweetcorn

❧

PRESSED FRUIT
Crab apple

ALL the pressed vegetable and fruit cards have a unique fascination. No one seems to associate fruit and vegetables with pressed botanicals but many of them press extremely well and, what is more, when cut into longitudinal and cross sections, they become an academic study in botanical structure. You do not necessarily need a garden or the countryside from which to gather these ingredients – a visit to the local supermarket will offer a cornucopia of ideas. Pressing fruit and vegetables is a matter of trial, error and expertise. Not everything will be a success but all failures will add something to the storage cupboard of experience. The smallest fruits and vegetables press into the most appealing botanicals – a newly formed French bean or seedling carrot has infinitely more refinement than its mature counterpart, so always try to acquire the smallest specimens unless the fruits and vegetables are to be sliced into sections.

SEEDLING CARROT CARD

1 Carefully glue two hand-torn strips of color-washed orange paper on the front of the card.

2 Arrange a selection of miniscule carrots on and between the paper strips. Lift the carrots and cover their backs with small dots of glue ½in (1cm) apart. Replace in position and press firmly in place.

3 Using a draftsman's pen, annotate the card.

VEGETABLES ON A COBWEB BACKGROUND CARD

1 Glue a square of hand-torn, green color-washed translucent paper on front of card.

2 Arrange a longitudinal section of okra, two tiny carrots, newly formed beans, a cross section of a small green tomato and a section of baby sweetcorn. Lift the vegetables and cover their backs with small dots of glue ½in (1cm) apart. Replace in position and press firmly in place.

3 Using a draftsman's pen, annotate the card.

CRAB APPLE CARD

1 Carefully glue a small rectangle of hand-torn, green colorwashed paper to the front of the card, as shown.

2 Arrange a thin section of pressed crab apple in the center. Lift the apple and cover its back with small dots of glue ½in (1cm) apart. Replace in position and press firmly in place.

3 Using a fine draftsman's pen, annotate the card, as shown.

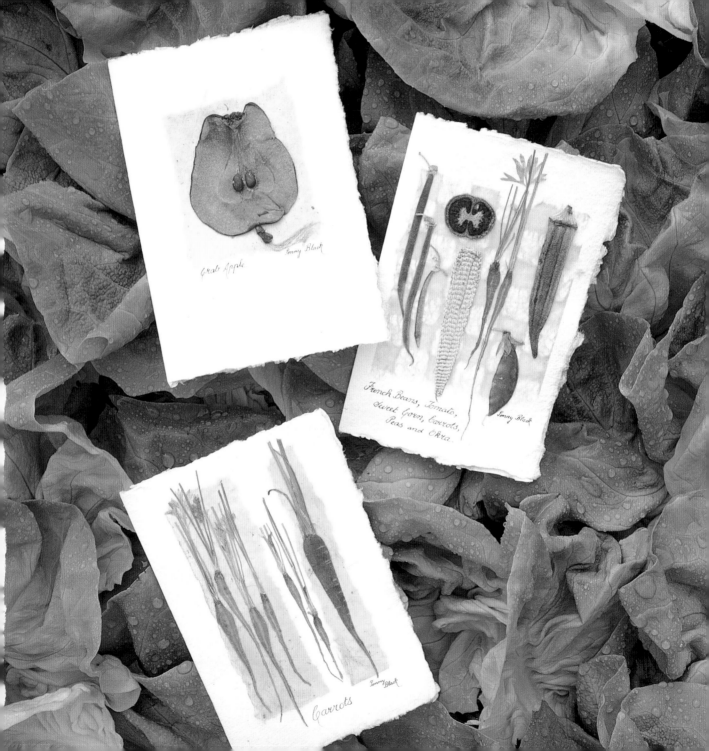

❧ FLOWERPOT CARDS ❧

Ingredients

Two folded blank cards 5½ × 3¾in
(14 × 9.5cm) and 4½ × 4in (11.5 × 10cm)
❧
Peat pot
❧
Rubber cement
❧
Watercolor
❧
Fine draftsman's pen
❧
BROWN CARD
Potentillas, lilac, geraniums, *Polygonum campanulatum*, rosebuds, grape hyacinths
❧
TURQUOISE CARD
Blackberries, pink pepper berries, callicarpa
berries, sterile hydrangea florets, rosebuds,
pink-dyed gypsophila, maidenhair fern

I HAVE always loved growing my flowers in pots. Crammed with herbs and geraniums, they filled the window ledges and porches of the country cottages of my childhood. Flowerpot cards have this same rustic appeal, and can be filled with any flowers, seeds, berries, spices, beans, mosses or lichens available. They are quick and easy to make and their endearing quality always arouses admiration.

BROWN POT CARD

1 To make the brown pot, carefully flatten a horticultural peat pot and cut out of it a small pot approximately 1½in (3½cm) in height and ¾in (2cm) wide at the base. Using the roughest side of the pot as the right side, very lightly glue it in place about one third of the way up the blank folded card.

2 The pot can now be filled with flowers and buds. Starting at the top of the arrangement and applying one or two small blobs of glue to the back of the botanicals, arrange the flowers and buds in place. Tuck some blossoms slightly behind others and spill the arrangement over the top of the pot. Press lightly in place.

3 Using a fine draftsman's pen, annotate the botanicals used, keeping the writing around the base of the pot.

TURQUOISE POT CARD

1 To make the turquoise pot, cut out a small peat pot measuring approximately 1in (2½cm) in height and ⅔in (1½cm) wide at the base. Colorwash the pot using barely diluted cobalt green paint. When it has dried, lightly stick it halfway up the blank card.

2 Beginning at the top and using very little glue, gradually build up a textured arrangement of berries, flowers and buds. The arrangement should cover the top of the pot.

3 Finally, to balance the collage, arrange a rosebud and a sprig of sterile hydrangea blossom either side of the pot.

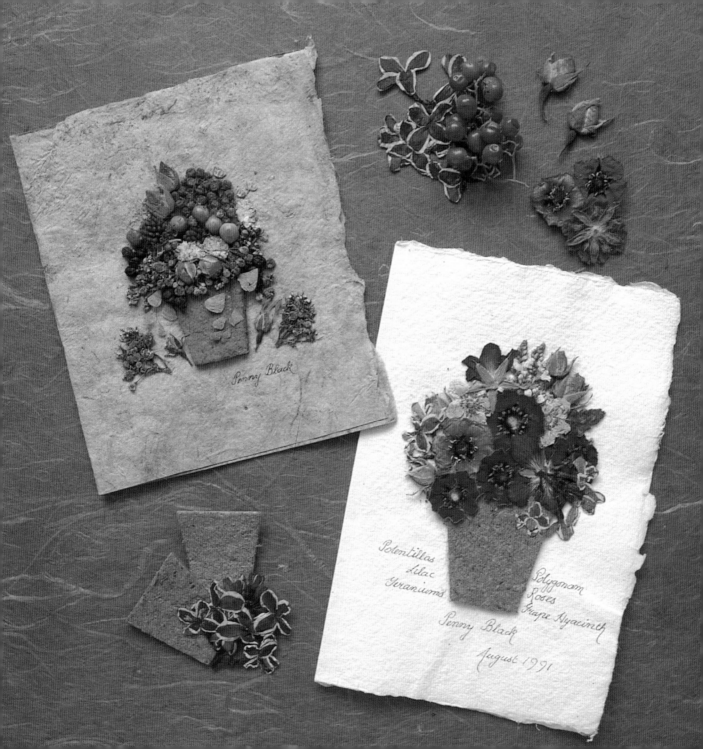

Penny Black

Potentillas
Lilac
Geraniums

Polygonam
Roses
Grape Hyacinth

Penny Black

August 1991

∾ "OLD HERBAL" CARDS ∾

Ingredients

Two folded blank cards 5 × 4in
(13 × 10.5cm)

∾

Rubber cement

∾

Brown paper

∾

Fine draftsman's pen

∾

PRESSED BOTANICALS
Blue columbine, mouse plant

O F all the cards in this book, the botanical ones are the easiest to make. Even the most humble weed becomes fascinating when isolated from its environment and displayed on a card of hand-made and hand-torn paper. Artistic arrangement is unnecessary as all one needs to see is a precisely arranged botanical specimen which has been clearly annotated with its Latin name. The charm of these cards is in their simplicity, reminiscent of a page from an old herbal. I generally like to use common or garden weeds for this type of card, but occasionally I will be tempted by a rarer plant that has a unique form, or perhaps an old-fashioned flower that has a particular association for me.

If you wish to evoke a feeling of the past with these cards, it is essential that the paper resembles the hand-torn paper of the early herbals. Hand-made paper is an obvious choice, but machine-made paper can look old and full of character when the edges have been torn rather than cut. The cards in this photograph have been made with textured hand-made paper.

COLUMBINE CARD

1 To make the small card, cover the back of the flowers, buds and stalk of a pressed blue columbine with smallest dots of glue and position them carefully on the card.

2 Using a draftsman's pen, write the plant's Latin name on a strip of hand-torn brown paper. Edge the label with fine black lines and glue alongside the flowers.

3 Finally, draw a fine black line at the top and bottom of the card just above and below the torn edges of the paper.

MOUSE CARD

The mouse card is made in a similar manner, using a larger piece of card and omitting the fine black rules.

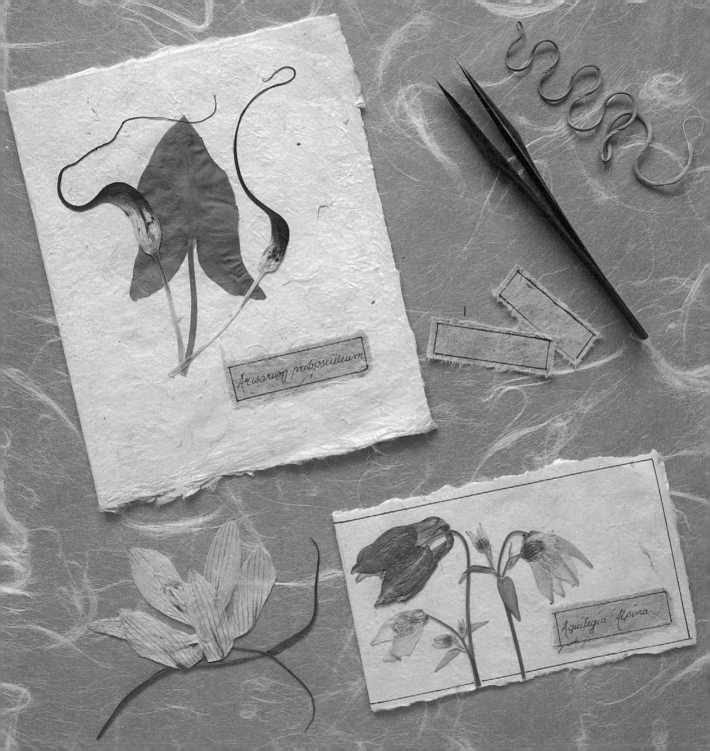

Arisarum probosciteum

Aquilegia Alpina

BINDWEED WRITING PAPER
AND CORRESPONDENCE CARDS

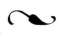

SHOULD the day ever come when I have time on my hands, then I will certainly make and decorate my own writing paper and correspondence cards. Large sheets of hand-made paper are quite widely available these days and they are not expensive. A sheet measuring 20 × 33in (50 × 85cm) will make approximately nine sheets of writing paper and quite a few assorted sized correspondence cards. These cards and sheets of writing paper can be hand-torn to size and decorated with the most humble wayside weeds. In fact one could easily make this botanical sta-

tionery without even possessing a garden.

I am fascinated by the organic lines of the lesser bindweed and, when pressed, it becomes a delicate art nouveau decoration. The intertwining stems and sagittate leaves have been of inspiration to the artist for centuries and, when using the actual pressed plant, it resembles a fine watercolor. If I was not constantly tempted by the heterogeneous plant world I could do no better than to decorate all my stationery with the common or garden lesser bindweed. The paper is creamy textured, hand-made and Indian.

WRITING PAPER

1 Arrange tendrils of lesser bindweed in top left hand corner.

2 Carefully lift the botanicals and cover the backs with small dots of glue ½in (1cm) apart. Replace and press firmly in position.

CORRESPONDENCE CARDS

Follow the writing paper instructions, but use a smaller bindweed specimen.

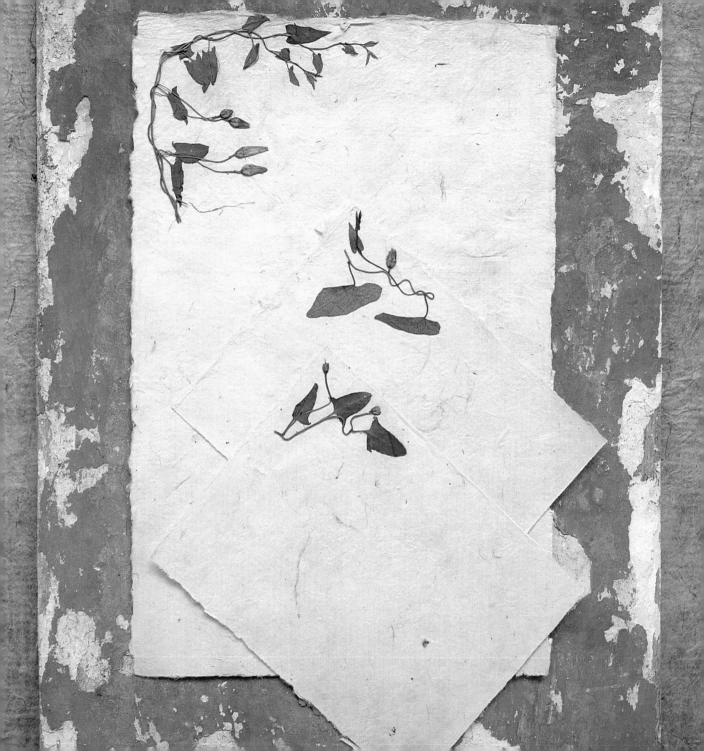

LARKSPUR WRITING PAPER AND ROSY LETTERCARD

Ingredients

Hand-torn sheets of writing paper 6¼ × 9in
(16 × 23cm)

Hand-torn correspondence cards 3¾ × 5in
(9.5 × 13cm)

Hand-torn letter card 8 × 10in (20 × 25cm)

White card and double-sided adhesive tape

Rubber cement and archival glue

PRESSED BOTANICALS
WRITING PAPER AND CARDS
Pink larkspur, goatsbeard

LETTERCARD
Rosebuds, rose leaves

A LL stationery is quick and easy to make and very few pressed flowers are needed. However, some artistry is required for the decorations must appear to be at ease with their background. I always press goatsbeard before it is fully out while the fronds are still apple green. Their color blends beautifully with pastel-shaded flowers and they can often replace leaves. The lettercard is an unusual way of folding paper and it requires no envelope to be sent through the post. I have painted these botanicals with a diluted solution of archival glue and this will ensure they remain intact when handled. All the papers used are cream and hand-made.

WRITING PAPER
1 Arrange botanicals on paper and glue in place.

2 Dilute ½ teaspoon archival glue with 1 teaspoon water and, using a fine brush, paint over botanicals.

CORRESPONDENCE CARDS
1 Arrange botanicals on cards, and glue in place.

2 Paint botanicals with diluted archival glue.

LETTERCARD
1 Cut out card template 7 × 3¼in (17.5 × 8.5cm) and place on sheet of writing paper as shown.

2 Fold paper around template in order of 1, 2, 3, 4 and then turn paper over and turn over small flap 5 over top face of lettercard.

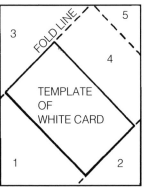

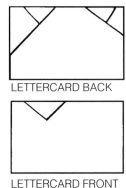

LETTERCARD BACK

LETTERCARD FRONT

3 Decorate small flap with botanicals and glue in place. Paint over botanicals with diluted archival glue.

4 Cut ¾in (2cm) strip of double-sided tape, remove one layer of covering and fasten on inside of flap 5. This will keep letter closed in the post.

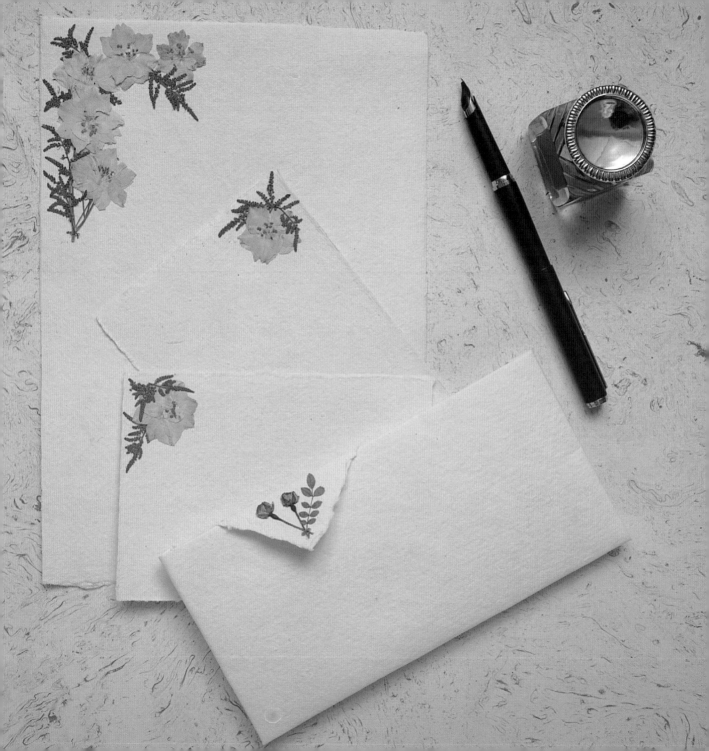

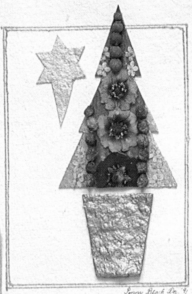

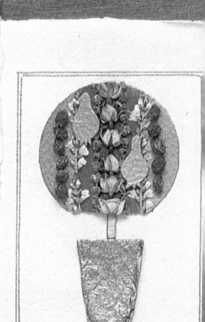

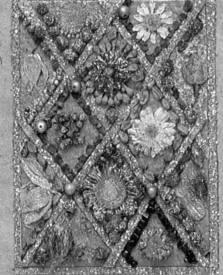

Penny Black Des. '91

Greetings

Penny Black Des. '91

Greetings

Penny Black

Happy Birthday

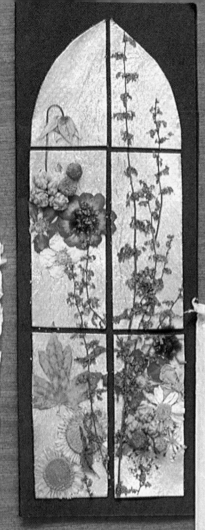

CARDS FOR
SPECIAL
OCCASIONS

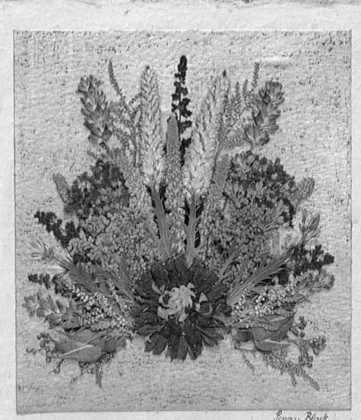

Penny Black

BIRTHDAY CARDS

Ingredients

Two folded blank cards – one 4×6in
(10×15cm) and one 4×5¼in
(10×13.5cm)

Watercolor and fine draftsman's pen

Cream hand-made paper

Rubber cement

PRESSED BOTANICALS
ROSES CARD
Roses, rosebuds, pink chervil

MIXED ARRANGEMENT CARD
Goatsbeard, salad burnet, Sweet Cicely,
lavender, rosebuds, geraniums, achillea,
Clematis recta, Polygonum superbum,
bramble flowers, astilbe, *Alchemilla mollis*

Pretty flowery collages make delightful birthday cards. They reflect the thought and effort that has gone into their making and are more personal than any card that has been bought. Even the most simple botanical card displaying a handwritten message will be memorable, particularly if the chosen flower ranks among the recipient's favorites. Garlands, posies, bouquets and interesting mixed arrangements of flowers are all "Birthday" collages. The flowers can reflect the season, or can perhaps just be chosen for their color and form. Even a display of pressed seedheads on rough brown paper could be appropriate for someone not orientated towards pretty dainty cards. I always enjoy making birthday cards because they are created with a specific person in mind and they do, of course,

represent a token of affection or friendship. My cards are quite different in style but both evoke a feeling of celebration. Cards decorated with roses always appeal. The display of mixed flowers, seedheads and herbs is more unusual and would be suitable for someone whose taste was not chintzy. The cards are of brown marbled paper and white machine-made paper.

ROSES CARD

1 On front of white card draw pencil rectangle 5×3¼in (12.5×8.5cm) and colorwash it pale mauve.

2 Arrange pink chervil, roses and rosebuds on mauve background, as shown, and glue in place.

3 Using a fine draftsman's pen frame decorated mauve background with two lines and write "Roses" in lower left corner of decorated card.

MIXED ARRANGEMENT CARD

1 On front of brown marbled card build up the display of botanicals. Starting with those at the back, and gluing as the arrangement progresses, continue until all the flowers, seedheads and buds are in place, finally completing the display with the large central rosebud.

2 Tear a strip of hand-made paper ½×2in (1× 5.5cm) and glue in place at base of arrangement as shown.

3 Using a fine draftsman's pen, write "Birthday Greetings" on strip of paper and glue in place on the card.

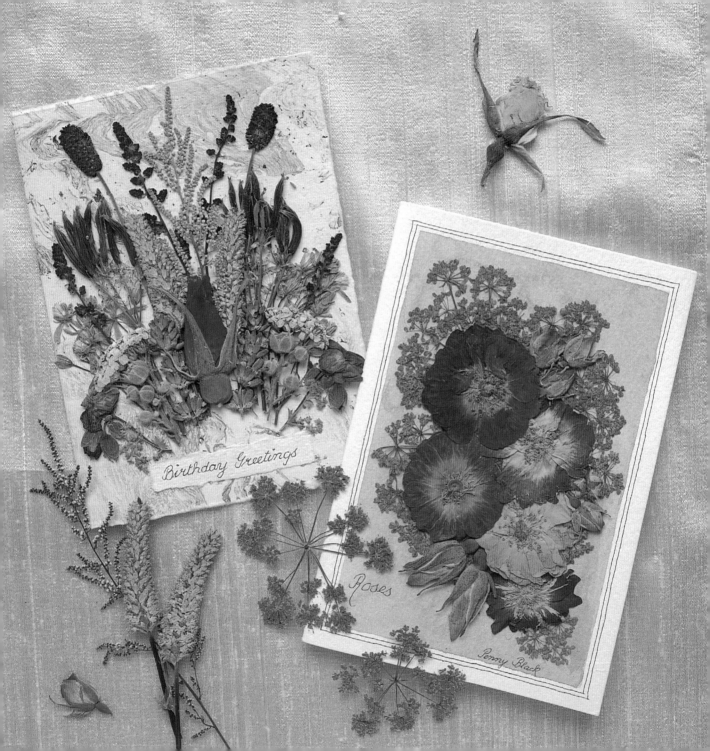

Birthday Greetings

Roses

Penny Black

VALENTINE CARDS

Ingredients

One folded blank card 5 × 6½in (13 × 17cm)

White card

Watercolor

Rubber cement

Fine draftsman's pen

PRESSED BOTANICALS
LARGE PINK CARD
Pink *Polygonum campanulatum, Hydrangea paniculata,* fuchsia, potentilla, single pink rose

SMALL VALENTINE HEART
Pink *Polygonum campanulatum,* fennel leaves, fuchsia, pink roses, *Polygonum* 'Superbum', *Anemone japonica*

VALENTINE cards presented quite a challenge to me. I had only made two previous ones and felt that artistic interpretation was going to be limited by convention. However, I need not have worried because my wayward style did rather lend itself to hearts and bowers and roses and all things romantic. In fact I really enjoyed making these somewhat fairytale tokens of love. The windowed heart of pink roses and green hydrangea blossom has a quaint prettiness that appeals while the small rose madder heart card randomly decorated with pink flowers is more discreet in style and a quieter manifestation of true love. In fact placed in an equally small envelope it has immense appeal, and if the envelope and heart are perfumed too, then love's potion is complete! Perfume them by sealing them in a plastic bag with pot pourri for a couple of days. The large card is white hand-made paper.

LARGE PINK CARD

1 Colorwash card in deep rose, ensuring that the coverage is not too even and that a few smears and blotches remain.

2 Cut out a heart from the front of the card 3½in (9cm) high and 4in (10cm) wide.

3 Colorwash the inside facing page of the card apple green. On the apple green background arrange a pretty and haphazard collage of pink and green flowers, ensuring that the single pink rose will be in the center of the heart window when the card is closed. Glue botanicals in place.

4 Close card and arrange flowers around lower half of heart. Glue in place. Using draftsman's pen, write "To My Valentine" on front of card.

SMALL VALENTINE HEART

1 Cut out a heart, 3½in (8.5cm) high × 3½in (8.5cm) wide, from white card and colorwash it in deep pink.

2 Decorate card with a random collage of pink flowers and a few green leaves (see p.20), leaving background undecorated.

3 Trim away any excess botanicals from edge of the card.

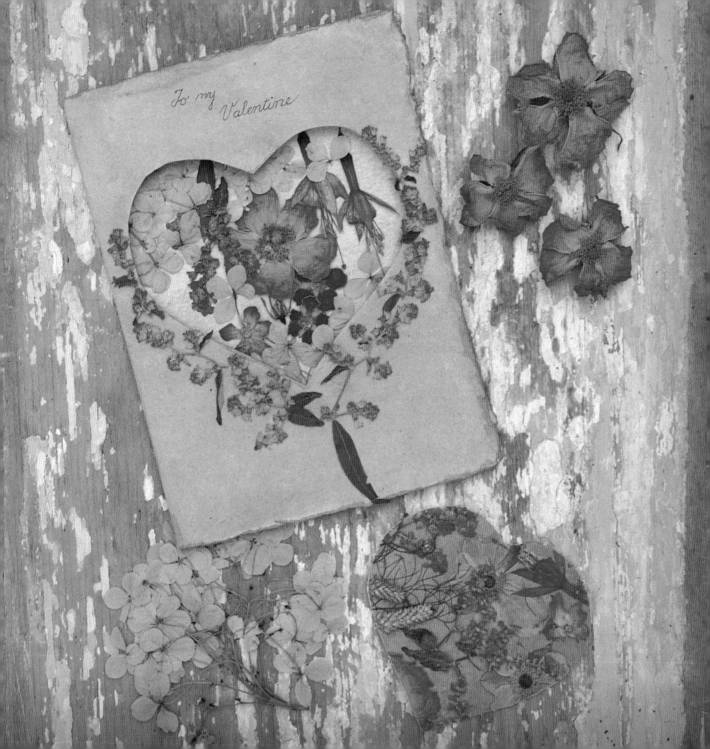

SILK WEDDING CARD AND TAG

Ingredients

Blank folded card 5 × 8¼in (13 × 21cm)

Brown silk and cream hand-made papers

Fine draftsman's pen

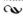

Rubber cement

Narrow white ribbon

PRESSED BOTANICALS

Muehlenbeckia, astrantia, larkspur (pink, white and blue), potentilla, achillea (red and white), alkanet, blue sterile hydrangea florets, anaphalis, chervil, potentilla, orange blossom

WEDDING cards are important and only the best flowers and loveliest backgrounds should be used. I like to be traditional and decorate my cards with large posies of flowers mixing flat blossoms with three-dimensional flowers. Pretty chervil umbels, diminutive sprays of alkanet, textured anaphalis blossoms and thick layers of achillea flowers have created an interesting edge to this posy, while the center is crowded with flat blossoms of astrantia, orange blossom, potentilla and larkspur. The trailing stems of small green leaves are from the climbing New Zealand plant Muehlenbeckia. Although the posy is traditional in concept, this time I have not used the customary wedding flowers of rosemary, myrtle, roses, orange blossom, forget-me-nots, lily-of-the-valley and love-in-a-mist. The ancient folklore surrounding marriage can be used as an inspiration for these cards, and what could be prettier and more symbolic than a tiny bouquet of myrtle and rosemary. The card is cream hand-made Indian paper.

WEDDING CARD

1 Cut a rectangle of brown silk paper 6¼ × 4½in (15.5 × 11cm).

2 Arrange and glue in place the botanicals that will edge the posy, keeping the arrangement towards the top of the brown silk background.

3 Arrange the flat blossoms in the center of the posy, sometimes putting one flower on top of another to give depth. Glue in place.

4 Intermingle sprays of three-dimensional anaphalis blossoms within the outer edge of the central flat blossom arrangement, once again adding to the depth of the posy. Glue in place. Arrange and glue the stems of Muehlenbeckia.

5 Tie a small bow of white silk ribbon and glue centre very lightly to arrangement, just above streamers of Muehlenbeckia. Twist trailing ends of ribbon and glue very lightly in place.

6 Lightly glue decorated brown silk paper rectangle to front of card.

7 Using draftsman's pen write "Congratulations," or another message, on front of card.

GIFT TAG

1 Cut a rectangle of cream handmade paper 4¾ × 3½in (12 × 9cm) and fold in half.

2 Cut a rectangle of brown silk paper 1¾ × 2½in (4.5 × 6.5cm) and glue to front of folded gift tag.

3 Arrange flowers on brown paper and glue in place. Thread ribbon through top of tag.

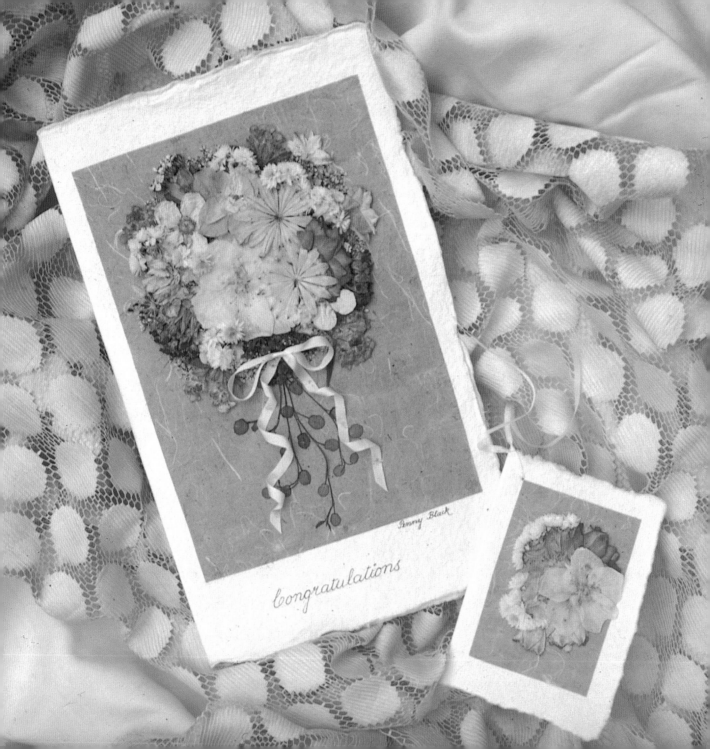

Congratulations

Penny Black

❧ ANNIVERSARY CARDS ❧

Ingredients

Folded blank cards: two 6 × 6¼in
(15 × 16cm) and one 4¼ × 5½in
(12 × 14cm)
❧
White card and hand-made silk paper
❧
Gold and silver leaf
❧
Rubber cement and gold sizing
❧
PRESSED BOTANICALS
GOLD CARD
Clematis, pink chervil, lavender,
aruncus, astilbe, rosebuds, eryngium leaves,
red achillea, filipendula, francoa, mignonette
❧
SILVER CARD
Pink larkspur, white larkspur, elder flowers,
white achillea, forget-me-nots, moss,
lichen, rosebuds, potentilla, feverfew
❧
WHITE CARD
Artemesia lactiflora, forget-me-nots, rosebuds,
pink *Polygonum campanulatum*, pink achillea, moss

WEDDING anniversary cards are quite special. I always gather together the loveliest of my pressed flowers for these collages and often spend a lot of time and effort in creating them, as I love to celebrate with flowers. Gold and silver leaf are quite easy to apply to card and I know of no more beautiful background for an arrangement of flowers in celebration of a golden or silver wedding. However, it is expensive and gold and silver paints and metallic watercolors make an excellent substitute. My garland of artemesia, forget-me-nots and rosebuds, displayed on white silk paper, could celebrate any wedding anniversary. I have used hand-cream cream and gray paper for these cards.

GOLD CARD

1 Cut out a rectangle of white card 5¼ × 5in (13.5 × 12.5cm). Cover with gold leaf (see p. 34).

2 Arrange pressed flowers in a crowded display, commencing with flowers at the back and working towards botanicals at the front of the display, gluing them in place as the arrangement progresses. Complete with central clematis flower.

3 Glue decorated background to front of card.

SILVER CARD

1 Cut out a rectangle of white card 5¼ × 5in (13.5 × 12.5cm) and cover with silver leaf as per instructions on p.34. Using a compass, pencil a circle 2in (5.5cm) in diameter, in center of silver background, slightly toward top.

2 Arrange pressed flowers and small tufts of moss in a garland, following penciled circle guideline. Glue in place. Arrange elder flowers around outside of garland and glue in place. Arrange forget-me-nots inside garland and glue in place.

3 Glue decorated background to front of card.

WHITE CARD

1 Cut out rectangle of white silk paper 4 × 4¼in (10 × 11cm). Using a compass, pencil a circle 2in (5.5cm) in diameter in center of white paper.

2 Arrange pressed moss on garland, following penciled guidelines, and glue in place. Arrange flowers on moss and glue in place. Arrange sprays of artemesia outside garland and glue in place.

3 Glue decorated background to front of card.

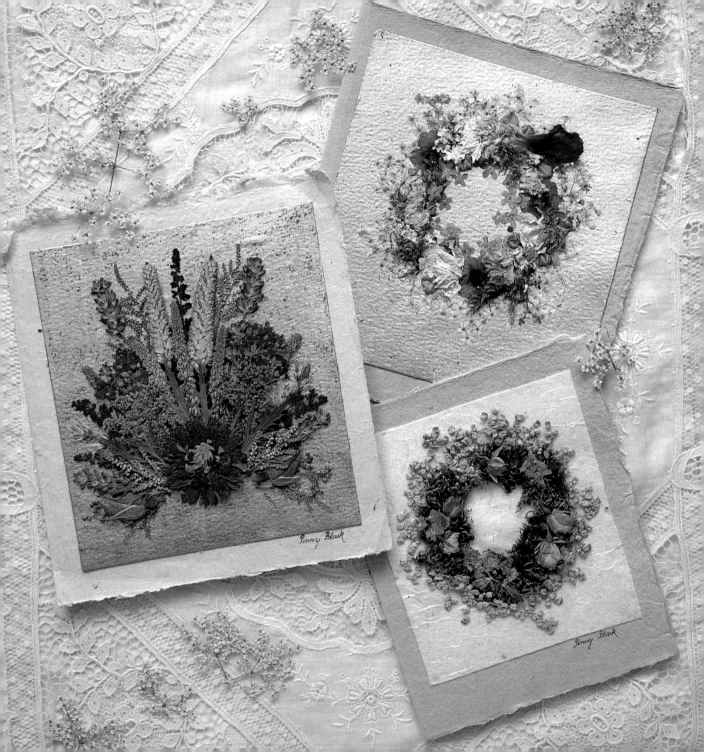

❧ CHRISTENING CARDS ❧

Ingredients

Three folded blank cards – two 6¼ × 2½in
(17 × 6.5cm) and one 5¼ × 3½in (13.5 × 9cm)

❧

Cream hand-made paper and pink and blue
colorwashed tissue paper

❧

Rubber cement

❧

Two 4¾in (12cm) lengths narrow ribbon,
one pink and one blue

❧

PRESSED BOTANICALS
Rosebuds, roses, forget-me-nots, rose leaves

I ENVISAGED making pretty pastel-colored chris-tening cards decorated with small but tradi-tional flowers. The diminutive blossoms, buds and leaves of any of the miniature roses seemed an obvious choice, as did pretty blue and white forget-me-nots. These christening collages could be framed and how pretty they would look deco-rating a nursery wall. The gift tags were made from small scraps. The cards and tags are made of simple creamy-white hand-made paper.

BLUE CARD

1 Tear a rectangle of blue colorwashed tissue paper 5 × 6¾in (13 × 17cm). Lightly glue it over an unfolded card of the same size.

2 Refold card (horizontally). Arrange roses, buds, leaves and forget-me-nots and glue in place.

3 Tear strip of pink tissue paper ½ × 3¾in (1.5 × 9.5cm). Lightly glue it on front of deco-rated card, as shown. Arrange roses, rosebuds, and forget-me-nots on strip of pink paper and glue in place.

PINK CARD

1 Tear a rectangle of pink colorwashed tissue paper 5 × 6¾in (13 × 17cm). Lightly glue it over unfolded card of the same size.

2 Follow step 2 of blue card.

WHITE CARD

1 Tear a rectangle of blue tissue paper 1½ × 2½in (4 × 6cm) and a strip of pink tissue paper ½ × 2½in (1 × 6cm). Lightly glue strip and rectangle to front of card as shown.

2 Arrange rosebuds, rose leaves and forget-me-nots on blue background and glue in place. Arrange rosebuds and forget-me-nots on pink strip and glue in place.

PINK GIFT TAG

1 Tear rectangle of creamy hand-made paper 1½ × 2¾in (3.5 × 7cm) and strip of pink tissue paper ¾ × 2¾in (2 × 7cm). Lightly glue pink paper background in center of white rectangle.

2 Arrange roses, rosebuds and forget-me-nots on pink background and glue in place. Thread length of narrow pink ribbon through top of tag.

BLUE GIFT TAG

1 Cut rectangle of cream hand-made paper 2 × 3½in (5 × 9cm). Tear rectangle of blue tissue paper 2 × 3½in (5 × 9cm). Lightly glue rectangle of blue paper to rectangle of cream paper. Fold tag in half.

2 Decorate front with roses, rosebuds and leaves and glue in place. Thread length of blue ribbon through corner of tag.

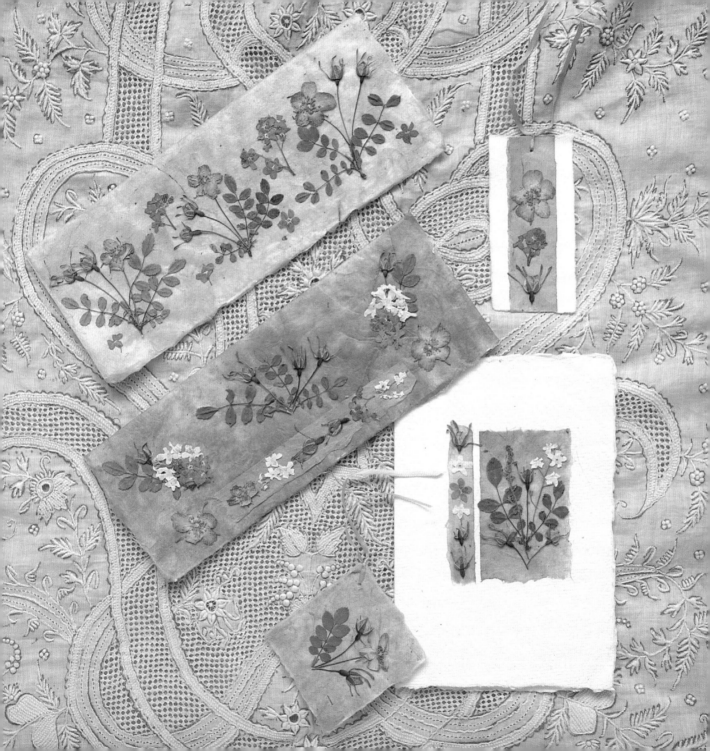

CHRISTMAS CARDS

Ingredients

Two folded blank cards 3¾ × 5½in (9.5 × 14cm)

White card and agricultural peat pot

Gold paint and watercolors

Fine gold pen and fine draftsman's pen

Rubber cement

PRESSED BOTANICALS
CHRISTMAS TREE CARD
Red potentilla, elder flowers, dried berries,
allspice, cotoneaster

PEAR TREE CARD
Rosebuds, white *Polygonum campanulatum*,
grape hyacinth, dried berries, rowan

THERE are endless possibilities when making Christmas cards. It is essential to include metallic paints, red and green colorwashes and perhaps glitter and luster powders. Pressed flowers alone will not evoke a festive atmosphere, so display on bright backgrounds with holly, cotoneaster and rowan berries, spices and evergreen leaves. The cards are simple cream hand-made paper.

CHRISTMAS TREE CARD

1 Cut out template for Christmas tree 2½in (6.5cm) high and 1¾in (4.5cm) at base, as shown on card. Cut out template for pot 1¼in (3cm) high and ½in (1.5cm) at base. Cut out template for star 1¼in (3 cm) high.

2 On white card and using templates, draw around star and tree and cut out. On section of peat pot and using pot template, draw around pot and cut out. Paint star and pot gold.

3 On Christmas tree draw a ¾in (2cm) wide stripe longitudinally through the center. Paint either side of the stripe gold and colorwash stripe in bright red.

4 Arrange botanicals on tree and glue in place. Trim away any excess botanicals from edge of tree. Glue tree, pot and star on front of card.

5 Using gold pen, frame collage with a double line and with draftsman's pen write "Greetings".

PEAR TREE CARD

1 Cut out template for pear tree 2in (5cm) high and 2in (5cm) wide at broadest point. Cut out template for pear ¾in (2cm) long. On white card draw around template for tree and two pears and cut out. Paint pears gold.

2 Cut a strip of white card ⅒in (2.5mm) wide and ¼in (1cm) long for trunk and paint gold.

3 On tree draw ¾in (2 cm) wide longitudinal stripe through center. Through center of stripe draw a narrower ¼in (5mm) wide stripe. Paint gold, red and green, as shown.

4 Arrange botanicals on tree and glue in place. Trim away any excess botanicals from edge of tree.

5 Glue decorated tree, trunk and pot to front of card. Glue pears on decorated tree.

6 Follow step 5 of tree card.

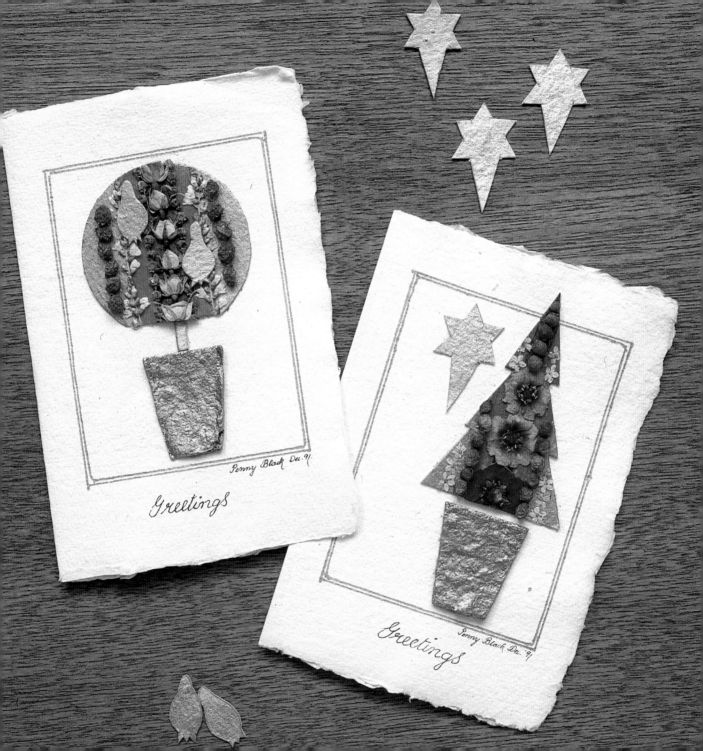

Greetings

Penny Black Dec '91

Greetings

Penny Black Dec. '91